The College History Series

COLLEGE OF
CHARLESTON

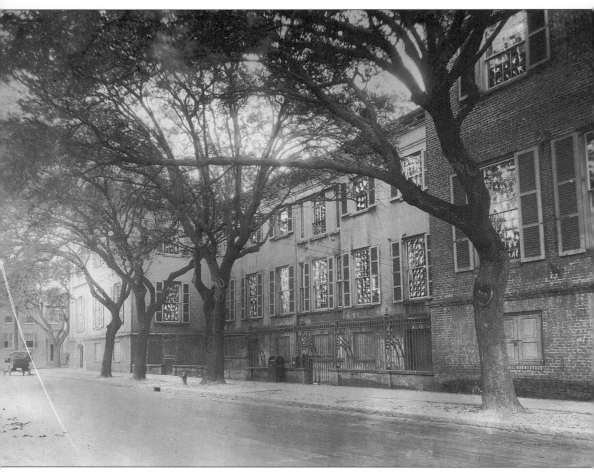

MAIN BUILDING, *c.* **1925.** The view is of the west wing of Main Building looking south, before the portico was added. Greenway is open to traffic. (Courtesy of Special Collections, College of Charleston Library, Charleston, SC.)

The College History Series

COLLEGE OF
CHARLESTON

ILEANA STRAUCH AND KATINA STRAUCH

ARCADIA

Published by Arcadia Publishing,
an imprint of Tempus Publishing, Inc.
2 Cumberland Street
Charleston, SC 29401

Printed in Great Britain.

Library of Congress Catalog Card Number: 00-106473

For all general information contact Arcadia Publishing at:
Telephone 843-853-2070
Fax 843-853-0044
E-Mail sales@arcadiapublishing.com

For customer service and orders:
Toll-Free 1-888-313-2665

Visit us on the internet at http://www.arcadiapublishing.com

*This volume is dedicated to my loving family and friends
who helped and encouraged me in this enterprise.
Thanks, Mom and Dad—I love y'all!
—IS*

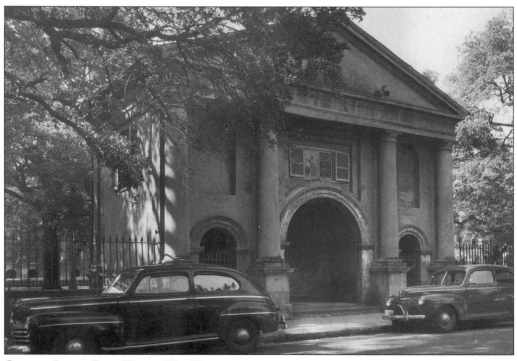

COLLEGE LODGE POST WORLD WAR II.

CONTENTS

ACKNOWLEDGMENTS

All my thanks to Marie Hollings for generously opening the resources of the Special Collections of the College of Charleston Library and to Gene Waddell for his encyclopedic knowledge and tireless assistance.

Thanks to Jane Thornhill, John Zeigler, Dan Ravenel, Scott Hall, Maggie Pennington, Tony Meyer, Mr. and Mrs. Louis Tannenbaum, Joe Cabaniss, and Gordon Stine for their time and reminiscences.

Thanks to Angie LeClercq for photos in the Daniel Library of the Citadel and David Heisser and Harlan Greene for steering me in the tangled trail of the research.

—Ileana Strauch

INTRODUCTION

In March of 1785, the General Assembly of South Carolina granted a charter for the establishment of a college in Charles Town, and lands were appropriated for its use. It opened in 1790, and the first commencement was held in 1794. It was the 11th college founded in the United States and the 15th to receive its charter. A second charter of 1791 assured that "no person shall be excluded . . . on account of his religious persuasion."

The original structure was a military barracks out from the city in rural environs. Charles Fraser wrote of being a student there in 1792, "I was at that time a pupil in the Charleston College which was kept in one of the old brick barracks . . . and which, with the corresponding one parallel to it . . . were almost insulated buildings. This latter was taken down about the same time, for I remember the helping hand which the boys gave at the ropes. We had quite a domain to the north and west for a campus, or playground."

In 1828, the ramshackle barracks were replaced by Main Building, now called Randolph Hall, and remained the principal structure for over 100 years. In 1837, the city of Charleston assumed control, making the College the first municipal college in the United States.

While the College has grown over the years from a handful of students to close to 9,000, the original plot of land still remains at its center as one of the loveliest campuses in America and an Eden little known to the hordes of visitors to Charleston. Every effort has been made to preserve the character of the neighborhood and to move and renovate historic structures, which are among the oldest survivors of the city.

COLLEGE OF CHARLESTON
Founded 1770
Chartered 1785

Original Building occupied West side of Campus,
extending from George St. to the present Green St.

Central portion of present Main Building
Erected 1828 ~ ~ Wm. Strickland, Archt.

Entrance Lodge, Portico and Wings of Main Building
Erected 1850 ~ ~ E. B. White, Archt.

Library
Erected 1855 ~ ~ G. C. Walker, Archt.

Wings of Main Building destroyed by
Earthquake in 1886. Rebuilt: East Wing with
Tower addition in 1888: West Wing in 1894

Alumni Entrance and Stairway
Erected 1927 ~ ~ Albert Graeser, Archt.

West Extension, Main Building
Erected 1930 ~ ~ Simons and Lapham, Archts.

COLLEGE HISTORY. This plaque, placed in the west wing of Main Building in 1930, outlines the history of the college. (Courtesy of Special Collections, College of Charleston Library, Charleston, SC.)

One

HISTORY

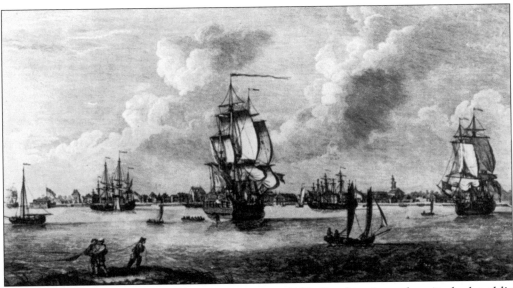

CHARLES TOWN, CAPITAL OF SOUTH CAROLINA, *c.* 1768. By this time, the city had public lectures, musical entertainment, theaters, and a public press. Members of the Library Society devoted themselves to "collecting materials for promoting a Natural History of this Province," and to establishing an academy. They applied to the Colonial Assembly for funds. Opposition held that "learning would become cheap and too common, and every man would be for giving his son an education." John Mackenzie of Broom Hall in the parish of St. James Goose Creek bequeathed £1,000 sterling and 800 books to the Library Society to be held for the College when it was finally realized. Miles Brewton, whose house on King Street still bears his name, provided a similar amount. During the Revolution, Samuel Wainwright gave £300 and Mrs. Mary Ellis gave £700. Mrs. Ellis was the first woman whose name was associated with the College. (Courtesy of Special Collections, College of Charleston Library, Charleston, SC.)

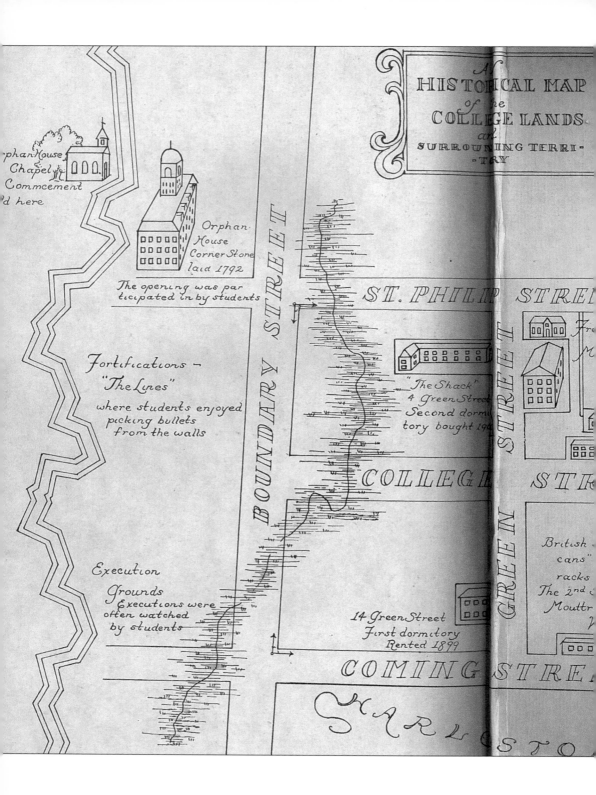

Orphan House & Chapel
Commencement
held here

Orphan House Corner Stone laid 1792

The opening was participated in by students

Fortifications —
"The Lines"
where students enjoyed picking bullets from the walls

Execution Grounds
Executions were often watched by students

BOUNDARY STREET

ST. PHILIP STREET

"The Shack"
4 Green Street
Second dormitory bought 19...

COLLEGE STREET

14 Green Street
First dormitory
Rented 1899

GREEN STREET

British ...
cans"
racks
The 2nd ...
Moultr...

COMING STREET

KARLESTO...

An
HISTORICAL MAP
of the
COLLEGE LANDS
and
SURROUNDING TERRI-TRY

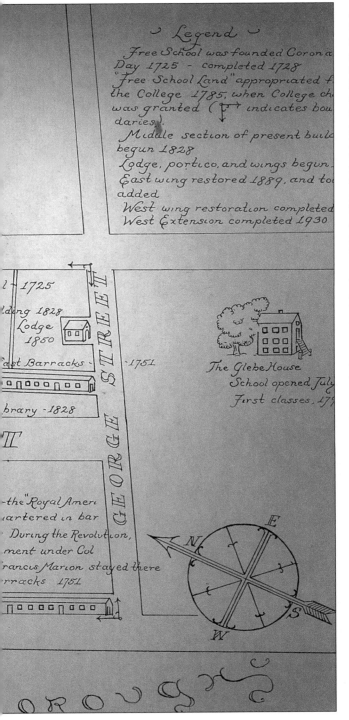

~ *Legend* ~

Free School was founded Corona
Day 1725 - completed 1728
"Free School Land" appropriated f
the College 1785, when College ch
was granted (↱ indicates bou
daries).
Middle section of present build
begun 1828
Lodge, portico, and wings begun
East wing restored 1889, and to
added
West wing restoration completed
West Extension completed 1930

l - 1725
lding 1828
Lodge
1850
ast Barracks - *-1751*
brary -1828
II
-the "Royal Ameri
artered in bar
During the Revolution,
ment under Col
rancis Marion stayed there
rracks 1751

GEORGE STREET

The Glebe House
School opened July
First classes, 179

N E S W

OROUGH

A HISTORICAL MAP OF COLLEGE GROUNDS. After the Revolution, many benefactors were reduced in fortune, others were exiled. A sectional division had arisen between the Lowcountry and the interior of the state, which demanded its own schools. The political deal cut in 1785 provided for three colleges—one in the Upcountry, one in the middle of the state, and one in the Lowcountry. The other two never materialized, perhaps because Charleston was the only one to receive a subsidy, in the form of 10 acres of land bounded by George, St. Philip, Boundary (Calhoun), and Coming Streets. It was desired that the College be outside the city limits (beyond Beaufain Street) to better serve the rural county and "in Order that the boys might be prevented from doing Mescheif." The site was a barracks "out of all repair" where the Royal American Regiment had been quartered during the French and Indian War. Calhoun Street was then known as Boundary Street. Across from the College was the Tyburn—or hanging tree—of Charleston. Public executions were popular entertainment in those days. The miniaturist Charles Fraser wrote, "I remember once seeing one of the gentler sex step gracefully from the scaffold into the air." (Courtesy of Special Collections, College of Charleston Library, Charleston, SC.)

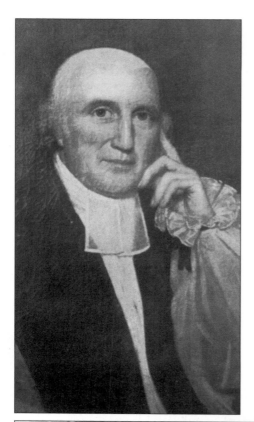

THE REVEREND ROBERT SMITH, PRESIDENT 1790–97. Reverend Smith was educated at Cambridge University and ordained a priest of the Anglican Church. Much admired for his support of the Revolution and his service as a common soldier during the siege of Charleston, he became the first president or "principal" of the College and afterwards the first bishop of South Carolina. A former student wrote, "He presided with great dignity and address, and had more power over boys, than any one in a similar capacity, whom I have every known, although never severe nor morose." (Courtesy of Special Collections, College of Charleston Library, Charleston, SC.)

SIX GLEBE STREET, C. 1770. As a rector of St. Philips' Episcopal Church, Dr. Robert Smith built a house on Glebe Street (or church lands). When he became the first principal of the College, some classes were held in his home. At the time, the house would have stood virtually alone, with an unobstructed view over the run-down barracks to Boundary Street. Charles Fraser watched the public hangings from the attic of this house. (Courtesy of Special Collections, College of Charleston Library, Charleston, SC.)

CHARLES FRASER, MINIATURIST. Fraser was a graduate of the College, a lawyer, and a painter of miniatures. He left one of the few descriptions of student life in the earliest days. He later became a trustee for an astonishing 43 years and secretary and treasurer of the College from 1825 to 1855. His gift of books to the library, along with those of Mitchell King, nearly doubled the volumes from 7,000 to nearly 14,000. Fraser's accounts tell us what little we know of student life at the time. The college day opened and closed with prayer, the morning one in Latin, the evening in English. The land around the College consisted of open fields cut by creeks and marshes. For fun, students played at ball and shinny, swam from Cannon's Bridge, and dug musket balls out of the old ramparts. (Courtesy of Special Collections, College of Charleston Library, Charleston, SC.)

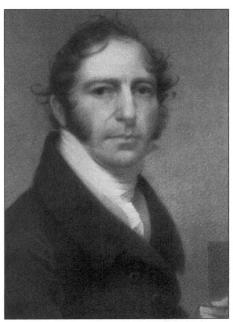

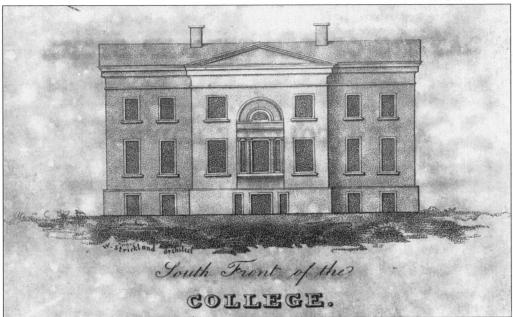

MAIN BUILDING, SOUTH FRONT OF THE COLLEGE. In 1828, the cornerstone of Main Building was laid, and corn, wine, and oil poured upon it while a Masonic choir sang. Gov. William Moultrie and Lt. Gov. Charles Drayton were among the first trustees. Arthur Middleton and Thomas Heyward were both signers of the Declaration of Independence. Charles Pinckney and Arnoldus Vanderhorst later became governors. John Rutledge became chief justice of South Carolina and of the United States. Dr. Oliphant had been surgeon general of South Carolina. Gabriel Manigault was the talented architect whose work remains timeless. (Courtesy of Special Collections, College of Charleston Library, Charleston, SC.)

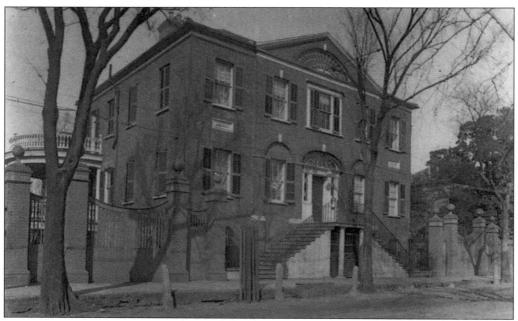

THE BLACKLOCK HOUSE, BUILT c. 1800. To picture the College in its earliest days, try to imagine this house standing alone, surrounded by unpopulated land with creeks and marshes. William Blacklock was a wealthy wine merchant who constructed 18 Bull Street with Adamsesque architecture of Charleston brick with walls 18 inches thick. The Blacklock House is shown here in 1920. As time wore on, it became a boardinghouse and a fraternity house for Medical College students. A permit was issued for its demolition in 1958, but it was saved at the last minute and later rebuilt by Richard H. Jenrette, who generously gave it to the College. (Courtesy of Special Collections, College of Charleston Library, Charleston, SC.)

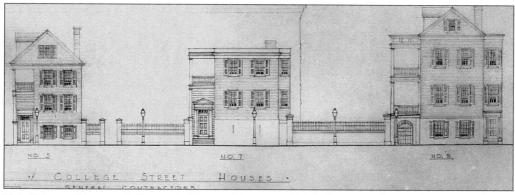

THE BOLLES HOUSE, 7 COLLEGE STREET, BUILT c. 1807. Because the College was always lacking funds, lands were divided in four parts around 1797 by the intersection of Green and College Streets, which was cut through the property. The Cistern area was reserved for the College and the other three areas were leased. The Bolles House still stands from this era. Abiel Bolles came from Connecticut to open a school for girls in 1807. He built 5 College Street, and as the school grew, 7 and 9 (the Erckmann House). The Erckmann House (c. 1835) was the site of the Book Basement from 1947 to 1971. (Courtesy of Special Collections, College of Charleston Library, Charleston, SC.)

THE FARR HOUSE, 69 COMING STREET, BUILT C. 1817. This marvelous home was built by Nathaniel Farr and his wife, Katherine (daughter of William Blacklock), on a parcel of the Blacklock land. The abundant marshes in the area were a mosquito breeding ground, and with no summer vacation, Yellow Fever was a deadly problem for the College. Faculty would often abandon their duties and seek the better air of Sullivan's Island. The Rev. Robert Woodbridge was assured by his physician that "the air of the College was sufficiently pure," but died in 1800 of the "prevailing disorder." A Doctor Gallagher stated he was compelled to resign by the "imperious law of self-preservation." A Mister Hicks of New Bedford, MA, fled the fever in 1803 after only a year's service. The third principal, George Buist (1806–1808), died of an illness of three days duration. The Rev. Dr. Elijah Dunham Rattoone accepted the principalship in 1810, but died of the fever in two months. (Courtesy of Special Collections, College of Charleston Library, Charleston, SC.)

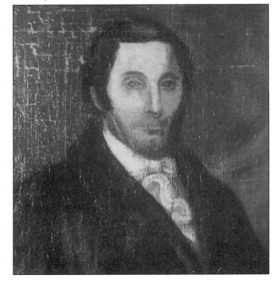

SIMON FELIX GALLAGHER, FACULTY MEMBER, 1793–1810. Educated at the College of Maynooth in Ireland, he came to Charleston as a Catholic priest to be rector of St. Mary's Church. He left his most enduring mark on the city by founding the Hibernian Society. Little is known of the early faculty. Certainly all of them were not happy, and the difficulty of retaining them almost dissolved the College. John Davis (c. 1805) only lasted for six weeks teaching Greek and Latin. He resigned and wrote: "Avert this lot! great God! I crave!/Redeem me from the toil of schools!/I was not born to be a slave,/Or dully wise to suckle fools!" (Courtesy of Special Collections, College of Charleston Library, Charleston, SC.)

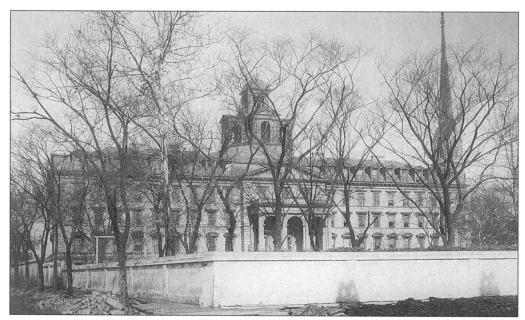

THE CHARLESTON ORPHAN HOUSE. Always in debt, the College struggled along as a grammar school. In the mid-1790s, the city built a large brick orphanage, the largest building in the city, across Boundary Street from the College grounds. College students were present at the dedication and laying of the cornerstone in 1792. By the 1850s, it had been remodeled in an Italianate style and housed 360 orphans. The cupola held both a figure of "Charity" and the city's huge fire-alarm bell. Its destruction for a Sears Roebuck store was the single most wanton act of desecration of historic Charleston. (Courtesy of *Charleston South Carolina in 1883*, Arthur Mazyck, the Heliotype Printing Co., Boston.)

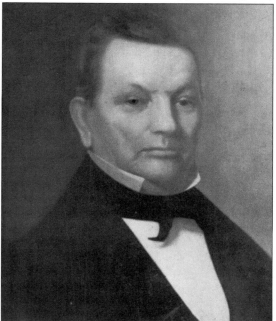

THE HONORABLE KERR BOYCE, FOUNDER OF BOYCE SCHOLARSHIPS. From the beginning, the College accommodated the needy. City scholarships were created in 1851 with the mayor and three aldermen each naming a scholar. In 1856, the Hon. Kerr Boyce bequeathed $30,000 for the first endowed scholarships. The revenue was divided among four students, providing them with tuition and money for necessities. The number of recipients was later increased with each student receiving a smaller sum than the previous ones. In 1897, the Boyce money was supporting 10 students, and other scholarships an additional 24. (Courtesy of Special Collections, College of Charleston Library, Charleston, SC.)

REV. DR. JOHN BACHMAN, FACULTY MEMBER 1848–1853. With Dr. Lewis R. Gibbes (Class of 1829, faculty member 1838–1892), he brought an illustrious reputation to the study of the sciences at the College, helping to establish the Horticultural Society in 1830 and the museum a decade later. A shared interest as naturalists brought him together with the animal artist John James Audubon. They co-authored *Viviparous Quadrupeds of North America* (3 vols., 1845–48), and two of Bachman's daughters married two of Audubon's sons. Bachman assembled a zoological collection for the museum, then housed on the top floor of Main Building, and donated his collection of geological and fossil specimens. With other naturalists, Bachman denounced P.T. Barnum's "Feejee Mermaid" as a glued-together monkey and fish for which a gullible public was paying 50¢ a peek. (Courtesy of Special Collections, College of Charleston Library, Charleston, SC.)

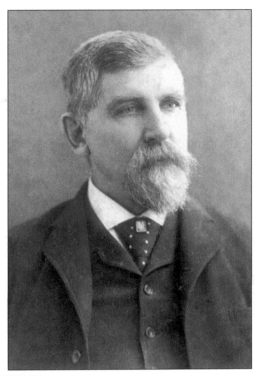

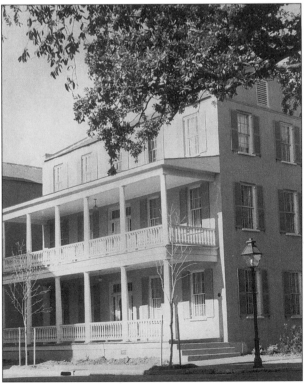

SEVENTY-TWO GEORGE STREET, BUILT c. 1837. This home is typical of those built on the land the College leased in the earliest days in an attempt to gain an income. By 1836, financial crisis had reduced the student body to 17 and the faculty to one. The College was placed under the patronage of the city and given an annual appropriation in exchange for title to the College property. Charleston was hurt badly by federal tariffs, and the revival of the College was part of a grand development scheme that included building a railroad to bring the Mississippi Valley trade to the port. When Physicians Memorial Auditorium was built, this house was rotated 90 degrees using wooden rollers with adjustments every 5 feet to avoid cracking. (Courtesy of Special Collections, College of Charleston Library, Charleston, SC.)

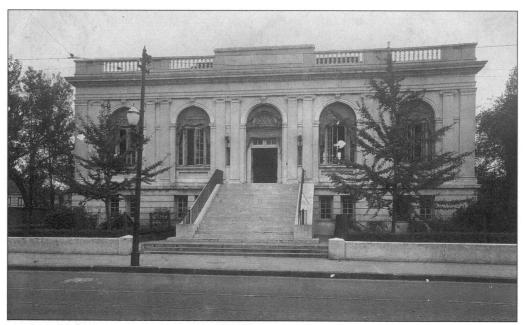

THE CHARLESTON LIBRARY SOCIETY ON KING STREET. The Charles Town Library Society was founded in 1748 with a collection of contributed books and pamphlets. As membership grew, it came to be the cultural center of the province. The Library Society, instrumental in the birth of the College, began in a room over the courthouse, moved to a bank building on Broad Street, and finally was located in this spot on King Street in the 1920s. The first books given to the College by John Mackenzie were destroyed by a fire in the Charleston Library Society in 1778. Thomas Grimké and other donors then pulled together 3,000 volumes, which were stored in a room above the chapel. These were frequently damaged by a leaking roof. (Courtesy Special Collections, College of Charleston Library, Charleston, SC.)

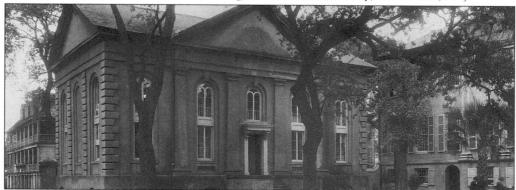

THE TOWELL LIBRARY. The construction of a college library became essential when, in 1853, Dr Lingard A. Frampton donated 4,000 "well-chosen" volumes. An appropriation of $8,000 by the General Assembly made possible the construction of a stuccoed brick building. Architect George C. Walker designed a classic Greek Revival structure with Italianate details. The bankruptcy of the contractor caused delays until it was finally opened in 1856. Much later, it was named for Edward Emerson Towell (Class of 1934), professor, dean, and acting president. The Cistern, built in 1857, completed the "College Green" that we know today. (Courtesy of Special Collections, College of Charleston Library, Charleston, SC.)

GABRIEL E. MANIGAULT, CLASS OF 1852, FACULTY MEMBER 1873–1899. As curator of the museum, he placed his emphasis on archaeology and art. The casts from the Parthenon that he ordered from England are still hanging in Randolph Hall. He also mounted over 100 skeletons, including that of a whale that had unluckily blundered into Charleston harbor. (Courtesy of Special Collections, College of Charleston Library, Charleston, SC.)

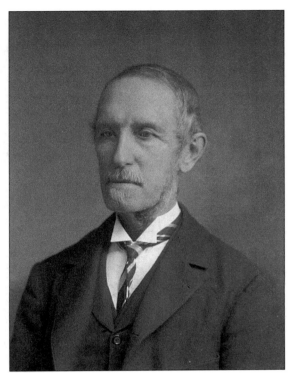

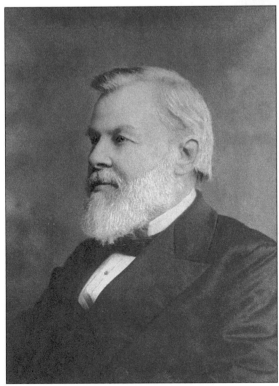

DR. LEWIS R. GIBBES, CLASS OF 1829, FACULTY MEMBER 1838–92. Educated as a doctor, Gibbes became a nationally known scientist in biology, chemistry, and astronomy. He was instrumental in the formation of the Elliott Society of Natural History in the 1850s. With Bachman, he entertained Louis Agassiz when he visited Charleston in 1847, and these friendships resulted in the formation of the museum. (Courtesy of Special Collections, College of Charleston Library, Charleston, SC.)

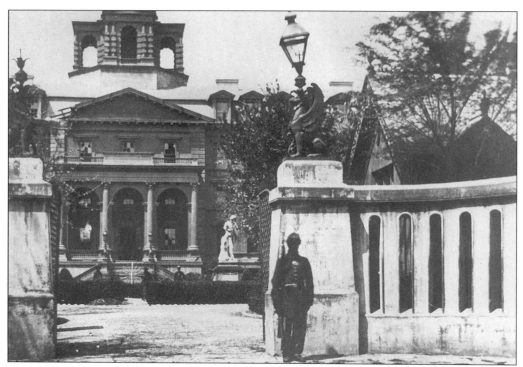

WAR OF SECESSION, CHARLESTON OCCUPATION, 1865. All eight members of the Class of 1864 served with the Confederacy and one, A.L. Hammond, died in battle. While Charleston was devastated by siege, the College was beyond the guns of the Union fleet. The library and museum collections were sent to the interior of the state where they miraculously escaped Sherman's arson. This scene shows a sentry from the 54th Mass. Rgt. at the Orphan House across Boundary Street from the College. (Courtesy of Special Collections, College of Charleston Library, Charleston, SC.)

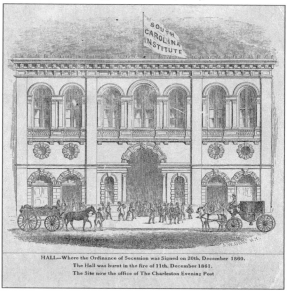

HALL—Where the Ordinance of Secession was Signed on 20th, December 1860.
The Hall was burnt in the fire of 11th, December 1861.
The Site now the office of The Charleston Evening Post

SOUTH CAROLINA INSTITUTE. The Ordinance of Secession was signed here in 1860 and announced from the balcony of the Charleston Hotel. One of the more illustrious graduates of the College, John Charles Frémont (Class of 1831), served as a general with the Union army. Guided earlier by Kit Carson, he had built a great reputation as a Western explorer and seized California for the U.S. during the Mexican War. This made him popular enough to be a Republican presidential candidate in 1856. But Stonewall Jackson made a fool of him during the war as he did so many others. (Courtesy of Special Collections, College of Charleston Library, Charleston, SC.)

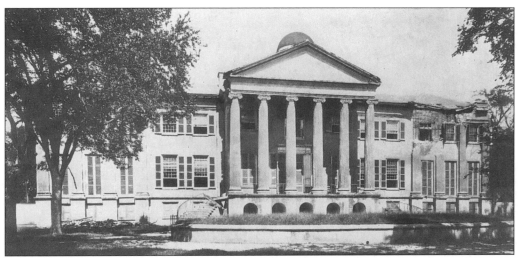

MAIN BUILDING AFTER THE EARTHQUAKE OF 1886. The night of August 31, 1886, Charleston was devastated by an earthquake that lifted land and buildings a foot in the air and spread fire everywhere. The two wings of Main Building were wrecked and the portico badly damaged. A freshman that year, Frederick Tupper wrote, "We dwelt long among the ruins learning this useful lesson—that the life of a College abides in its men, and not in its walls and towers." Incidentally, this was the year that Coca-Cola, Dr. Pepper, and Moxie all hit the market at the same time. (Courtesy of Special Collections, College of Charleston Library, Charleston, SC.)

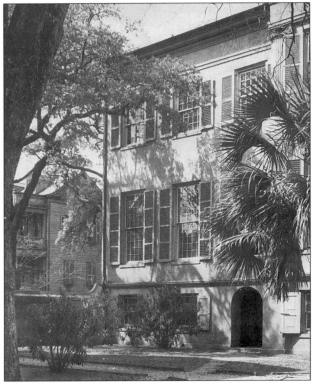

MAIN BUILDING WEST EXTENSION. Explaining why he pressed for campus improvements in 1850, Mayor Hutchinson said, "The state of the edifice was unsightly. The spacious Campus lay desolate, and the gloomy and repulsive brick wall seemed rather to inclose in its grasp the abode of criminals, than a temple dedicated to the progress of the mind." The result was the 1851 addition of a portico and outer wings to the old building, a porter's lodge, and iron railings in place of much of the wall. Oak saplings were planted replacing the mulberry trees. This scene is from 1930. (Courtesy of Special Collections, College of Charleston Archives, Charleston, SC.)

THE GRADUATING CLASS OF 1896. Dr. Randolph came the following year and promoted sports, which he frankly admitted was a way to attract students. In October 1897, the first football team had its first defeat, and in the spring of 1898 baseball was introduced. It is surprising that the College managed to field athletic teams in those lean years. The average enrollment around this time was 27, but Randolph refused to reduce the demanding math and classics requirements or to allow electives. (Courtesy of Special Collections, College of Charleston Library, Charleston, SC.)

DR. HARRISON RANDOLPH, PRESIDENT 1897–1945. Dr. Harrison Randolph (M.A., University of Virginia) was lured from the University of Arkansas to serve as president of the College in 1897 at the age of 24. The College had 5 faculty members, 36 students, and an annual budget of less than $13,000. Randolph added a bachelor of science degree and pre-med courses, and admitted women in 1918. Along with being president, he taught math, logic, and astronomy, which occupied 15 hours a week in the classroom. Main Building was renamed Randolph Hall in his honor in 1972. (Courtesy of Special Collections, College of Charleston Library, Charleston, SC.)

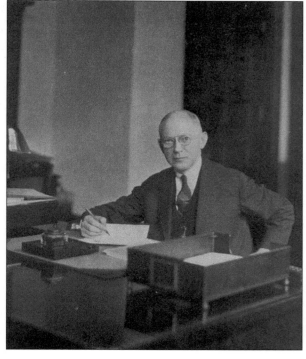

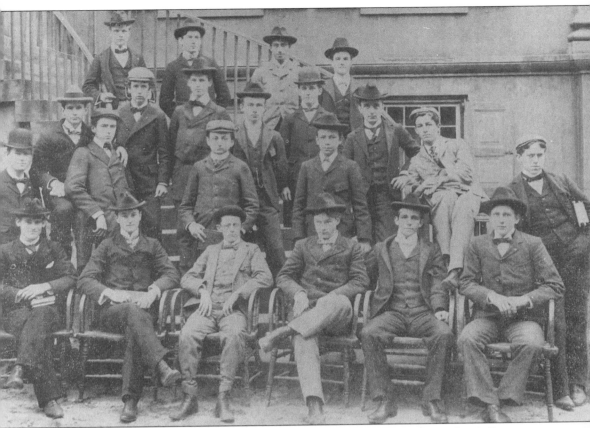

THE STUDENT BODY, 1898. President Randolph had come the year before. The College was perpetually poor, but its traditions and scholastic ideals were highly valued by the city. In a great act of curriculum reform, Randolph decreed that the study of both Latin and Greek was no longer required. You could select one and study the subject for as few as two years. It was the year of Manila Bay, San Juan Hill, and "There'll Be a Hot Time in the Old Town Tonight." (Courtesy of Special Collections, College of Charleston Library, Charleston, SC.)

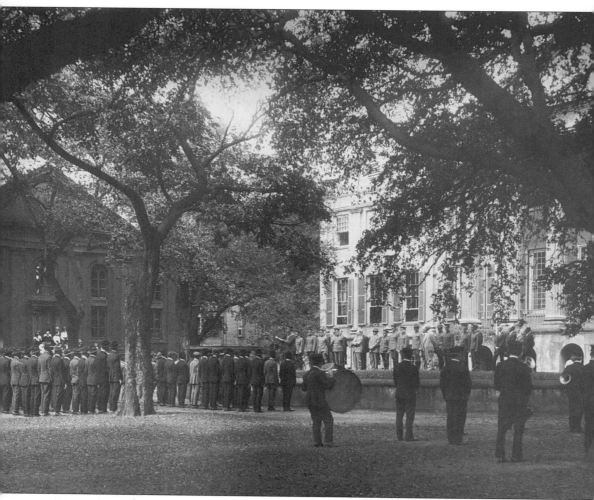

A WORLD WAR I COMMISSIONING EXERCISE. The 1917 *Maroon and White* noted that "Archie Baker is a member of the Field Hospital Corps, National Guard, and three other members of the (Junior) class expect to leave college before the end of the session to enter active service for the duration of the war." This picture was taken September 30, 1918, the very day women were admitted to the College. (Courtesy of Special Collections, College of Charleston Library, Charleston, SC.)

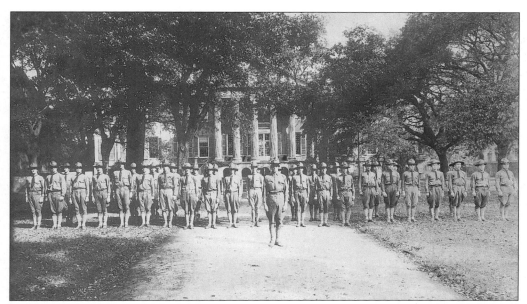

THE PLATOON GRADUATING CLASS OF 1918. With the coming of the Great War, all students were in the uniform of the Students' Army Training Corps, and the Shack was now called a barracks. The Lodge became a YMCA "hut." Bugles sounded reveille and retreat among the campus oaks. The *Maroon and White* of 1917 had this verse for senior Frank Spellman: "From habits pacific / To grim war terrific / The scholarly Frank Spellman turns. / He's shouldered a gun, / And to wallop the Hun, / All the zeal in him eagerly burns." (Courtesy of Special Collections, College of Charleston Library, Charleston, SC.)

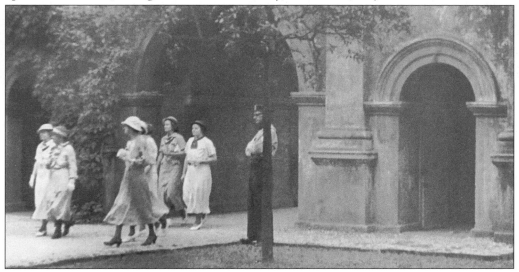

THE LODGE IN 1920s. While the novelty of "elective studies" came in 1917, the real shock came on September 30, 1918, with the enrollment of 10 female students. While there is an elaborate history of action by the City Federation of Women's Clubs, President Randolph probably admitted them for the same reason so many colleges went coed in 1970—fear of declining enrollment and the collapse of the school. (Courtesy of Special Collections, College of Charleston Library, Charleston, SC.)

THE GRADUATING CLASS, *c*. 1920S. The girls had come in 1918, but none of them are pictured in this group. Presumably it was taken before 1922, when Pierrine S. Smith was the first honor graduate of that year. The white pants are the first sign of the coming tradition of graduating in all white. (Courtesy of Special Collections, College of Charleston Library, Charleston, SC.)

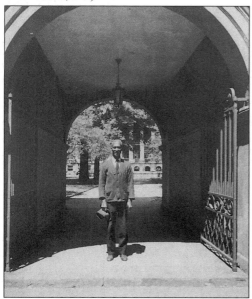

ROBERT THE COLLEGE JANITOR, 1930. The "Honorable Robert" was a full of stories of college life. When he came in 1904, the Lodge had students living in it, tennis courts were on the campus, and football lockers were under the library. He remembered the first breaking of the bell and was not fond of the presence of female students. He said in the 1930 *Comet*, "We didn't want them here in the first place, but they sneaked them into the school when President Randolph was in Washington during the war, and we just ain't been able to get rid of them since." He did admit that the young men behaved with much more dignity with the arrival of the co-eds. (Courtesy of Special Collections, College of Charleston Library, Charleston, SC.)

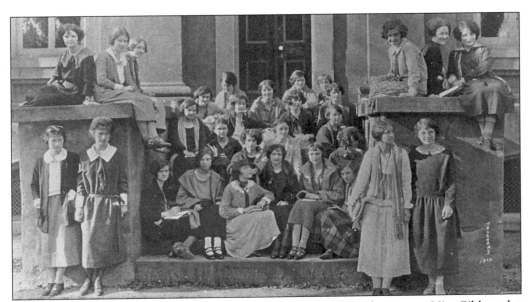

FEMALE PIONEERS, EARLY 1920s. The first enrolled women had a chaperone, Miss Gibbs, who escorted them to the library, but they were allowed to attend classes alone. They quickly adapted to college life, and by the second year had organized a women's basketball team. Late in life Mrs. Elias Vinning (a graduate of the College and one of the first female students) recalled, "The men did not accept us readily at first, but they dated us." Pictured is the campus YWCA. (Courtesy of Special Collections, College of Charleston Library, Charleston, SC.)

BURNET RHETT MAYBANK. The first honor graduate, Maybank was a member of the Class of 1919, mayor of Charleston, and the governor of South Carolina during the Depression. As an ardent "New Dealer" and friend of Franklin Roosevelt, he was able to secure the funding for the gymnasium on George Street in 1939 that replaced the old Charleston high school. (Courtesy of Special Collections, College of Charleston Library, Charleston, SC.)

ALFRED HUTTY, 1937. This prolific northern artist began spending his winters in Charleston in the 1920s, living in a house on Tradd Street. He was a part of of what is called the "Charleston Renaissance" and is famous for his etchings of the city before it became gentrified. He is shown here in 1937, when he gave art instruction at the College. (Courtesy of Special Collections, College of Charleston Library, Charleston, SC.)

THE MUSEUM, 1915. Charleston has long claimed its museum as the first in America. Sea captains turned over "the curious things they had garnered from the sea" and savants like Bachman and Gibbes contributed their collections. Francis Holmes, the first curator, uncovered mammoth, mastodon, and mylodon skeletons in the phosphate mines near the city. For 60 years, the museum was housed on the top floor of Main Building. Because the College needed that space, it handed the collection over to the city and it was moved to Thomson Auditorium in Cannon Park, a 35,000-square-foot structure built for the United Confederate Veterans Reunion in 1899. (Courtesy of Year Book 1908, City of Charleston SO. CA.)

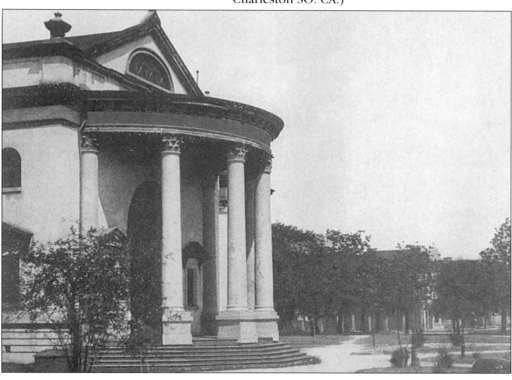

SAMUEL GAILLARD STONEY. A great Charleston character and author of *African Genesis* and other books on the Lowcountry, Stoney typically dressed in a plaid shirt and bowtie and rode a bicycle. His beard and sandals without socks were considered quite bohemian in a little Southern town, and folks whispered that he had learned these habits while living in Greenwich Village. In 1965 he gave courses in the history of art and architecture. (Courtesy of Special Collections, College of Charleston Library, Charleston, SC.)

MAGGIE T. PENNINGTON, PH.D. The first female professor at the College of Charleston, Dr. Pennington taught biology from 1962 to 1977. She did not know she was going to be the first woman until after accepting the job, and said, "I was welcomed by the faculty and students; it was wonderful and a lot of fun to work with them." When Pennington first taught there were 25 faculty members and 300 students, but when the College became a state institution in 1970 the numbers rose drastically. Pennington said the College was "a marvelous place to teach. They had small classes and the students were serious and sharp. The College was determined to always keep its reputation of high academic standards. A large percentage of the faculty were Ph.D.s." Pennington was the first, last, and only dean of women at the College. But she was grateful when the College decided they only needed one dean of students, and not a separate one for each sex. (Courtesy of Special Collections, College of Charleston Library, Charleston, SC.)

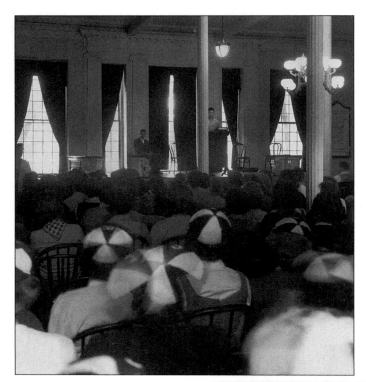

CHAPEL. Any freshman not wearing a "Rat Hat" was reprimanded by having to push a peanut with his nose across the length of the Chapel. Up until 1970, when the College of Charleston became a state institution, all classes and chapels where still held in Main Building. "Chapel was attended three times a week. The boys sat on one side and the girls on the other," Dr. Pennington remembered. (Courtesy of Special Collections, College of Charleston Library, Charleston, SC.)

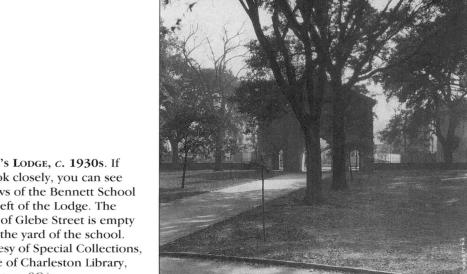

PORTER'S LODGE, *c.* **1930s.** If you look closely, you can see windows of the Bennett School to the left of the Lodge. The corner of Glebe Street is empty due to the yard of the school. (Courtesy of Special Collections, College of Charleston Library, Charleston, SC.)

Two

STUDENT LIFE

Sleeping Acquaintances

ALUMNUS: "By the way, did you know my old friend Jefferson Riley at the College?"

DICK: "Yeh, I used to sleep with him."

"Really; roommates?"

"No. Classmates."

CAMPUS HUMOR. (Courtesy of Special Collections, College of Charleston Library, Charleston, SC.)

DR. HANCKE WAGENER. An unusual number of College of Charleston professors had Ph.D.s for such a small college—many of them from quite illustrious institutions. Wagener had his A.B. from Harvard and his Ph.D. from Heidelberg. He began teaching French and German at the College in 1890. (Courtesy of Special Collections, College of Charleston Library, Charleston, SC.)

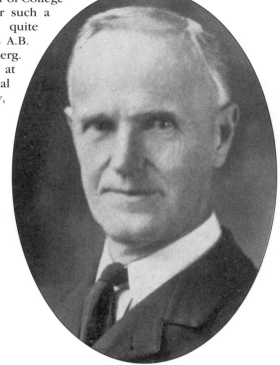

DR. LANCELOT HARRIS. Dr. Harris had his A.B. from Washington and Lee University and his Ph.D. from Johns Hopkins. He began teaching English at the College in 1898. (Courtesy of Special Collections, College of Charleston Library, Charleston, SC.)

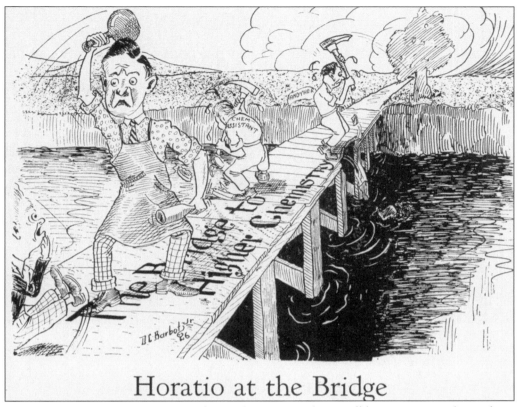

Horatio at the Bridge

ACADEMIC CAMPAIGNS. "Horatio at the Bridge" was a then well-known poem about three courageous Romans who held off an Etruscan army while others tore down a bridge over the Tiber. This is a reference to the rigor of academics at the College. (Courtesy of Special Collections, College of Charleston Library, Charleston, SC.)

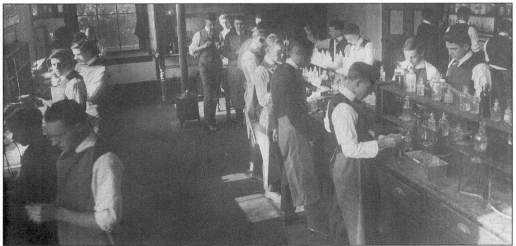

CHEMISTRY LAB. In 1916, the college catalogue boasted that labs were "provided with abundant light arranged so as to be available for both morning and afternoon work." (Courtesy of Special Collections, College of Charleston Library, Charleston, SC.)

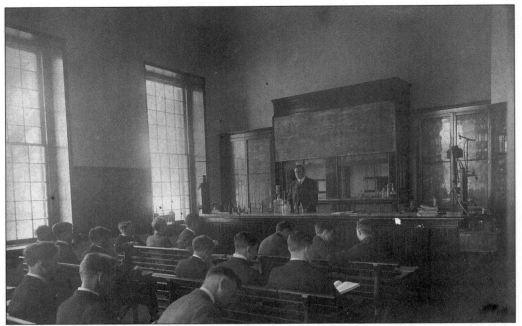

STUDENTS WORKING. Professor: "The originality of the excuses offered this year by the Freshman Class is unparalleled." (Courtesy of Special Collections, College of Charleston Library, Charleston, SC.)

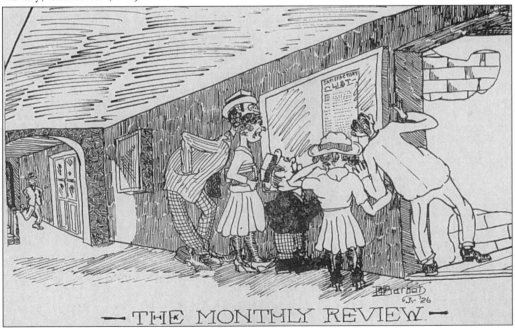

THE LOBBY, 1924. The basement of Main Building, called "the Lobby," served as the student union. It was a favorite spot for gossiping and girl-watching. This picture shows students checking their posted grades. (Courtesy of Special Collections, College of Charleston Library, Charleston, SC.)

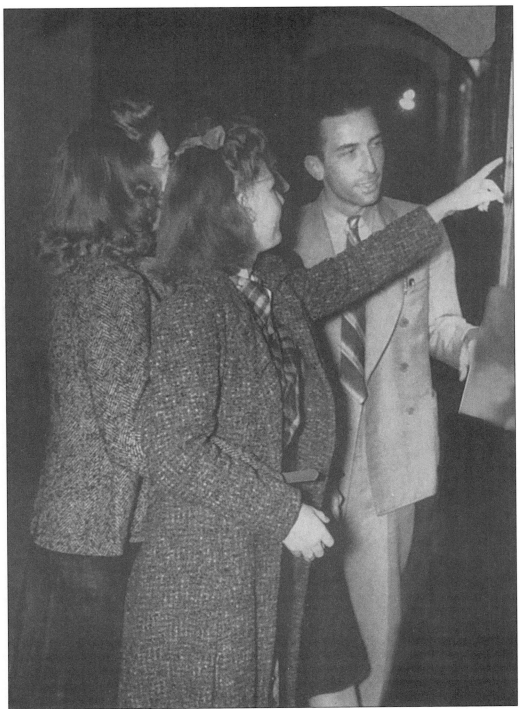

Plus ça Change. It's 1941 and the students are still nervously checking grades in the lobby of Randolph Hall. (Courtesy of Special Collections, College of Charleston Library, Charleston, SC.)

THE CHAPEL CHATTERERS

PLACE OF MEETING:—The Chapel

PASS WORD:—Tst-t-t-t!

As the name signifies, this club is made up of some of the more talkative of our Co-eds, who are accustomed to beguile that tedious period of roll-call with lively conversation—much to the annoyance of those in the near vicinity. The members have even been known occasionally to be so engrossed in the matter under consideration as to forget to answer to their names, thereby incurring the wrath of those higher up.

OFFICERS AND MEMBERS

Major Annoyances
 Laura Simons
 Marion Gayer
 Eleanor Gregg

Minor Nuisances
 Frances Gooding
 Pierrine Smith

CHIEF ADMONISHER:—Jeannette Webb

ASSISTANT ADMONISHER:—Frances Walton

STUDENT HUMOR, 1922. This appears to be a joke club for purposes of the yearbook. (Courtesy of Special Collections, College of Charleston Library, Charleston, SC.)

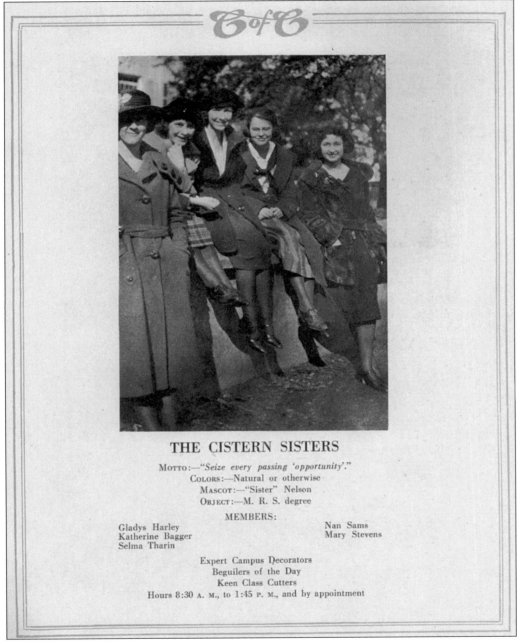

THE CISTERN SISTERS

MOTTO:—*"Seize every passing 'opportunity'."*
COLORS:—Natural or otherwise
MASCOT:—"Sister" Nelson
OBJECT:—M. R. S. degree

MEMBERS:

Gladys Harley Nan Sams
Katherine Bagger Mary Stevens
Selma Tharin

Expert Campus Decorators
Beguilers of the Day
Keen Class Cutters
Hours 8:30 A. M., to 1:45 P. M., and by appointment

STUDENT HUMOR, 1922. Hanging out at the cistern to meet boys was a popular event called "cisternating." In today's age of career women, no one jokes about the "M.R.S. degree." (Courtesy of Special Collections, College of Charleston Library, Charleston, SC.)

NOT LONG AFTER A DECISION BY ALL PRO-
FESSORS TO GIVE EXAMS LIKE GREASER'S

IMPRESSIONS OF THE FINE ARTS CLASS

HUMOR OF 1925. Clarence Graeser was a graduate of the College in 1888 and taught modern languages at the Citadel (1910–23) and the College, beginning in 1923. (Courtesy of Special Collections, College of Charleston Library, Charleston, SC.)

LESSER AND TANENBAUM. Louis Lesser's and Louis Tanenbaum's store was a fixture on King Street. When they opened in 1937, a suit of clothes sold for $12. The only true summer weight material was beautiful Irish linen, which could only be worn one time for a dressy occasion, and then became everyday wear (because it wrinkled so easily). (Courtesy of Special Collections, College of Charleston Library, Charleston, SC.)

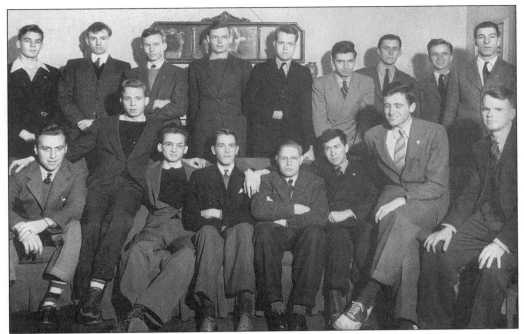

ALPHA TAU OMEGA, 1941. Chartered in 1889, Alpha Tau Omega is the oldest fraternity on campus. Fashion for 1941 included bold striped socks, dirty bucks, and the classic "Joe College" tweed jacket. In the slang of the time, "Worthy Master" McKenzie Moore (fifth from left, with arms crossed and a determined look on his face) was described as a "dog-gone" swell fellow. (Courtesy of Special Collections, College of Charleston Library, Charleston, SC.)

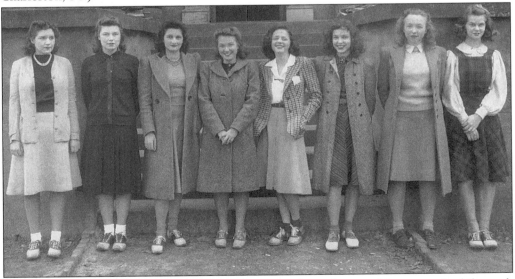

WOMEN'S PAN-HELLENIC, 1941. These representatives from the sororities supervised the rush season and set dates for sorority formals. This organization also sponsored the annual beauty contest. All but one are wearing white buck shoes, and their dresses all hit below the knee. (Courtesy of Special Collections, College of Charleston Library, Charleston, SC.)

STUDENT HUMOR, 1946. A quite accurate caricature of Paul Russell Weidner, professor of English, is pictured in the 1946 *Comet*. (Courtesy of Special Collections, College of Charleston Library, Charleston, SC.)

PAUL RUSSELL WEIDNER, A.B. UNIVERSITY OF MIAMI, A.M. HARVARD, PHI BETA KAPPA. Professor Weidner was the sort of talented and inspirational teacher who existed in the golden days before academe became obsessed with the "professionalism" of churning out long lists of publications. (Courtesy of Special Collections, College of Charleston Library, Charleston, SC.)

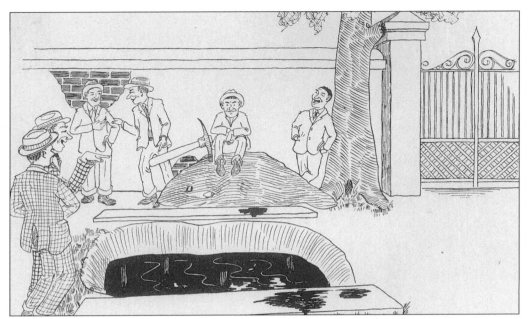

FRESHMAN INITIATION, 1925. For many years, an old pump stood in the yard of the campus. It was particularly useful for filling a hole with mud . . . (Courtesy of Special Collections, College of Charleston Library, Charleston, SC.)

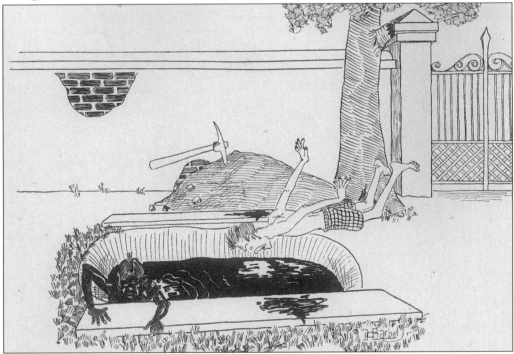

FRESHMEN INITIATION, 1925. . . . and making the freshmen jump in. College Humor: Leland: "I want you to know, I'm a self-made man." Vinson: "Well, who interrupted you?" (Courtesy of Special Collections, College of Charleston Library, Charleston, SC.)

41

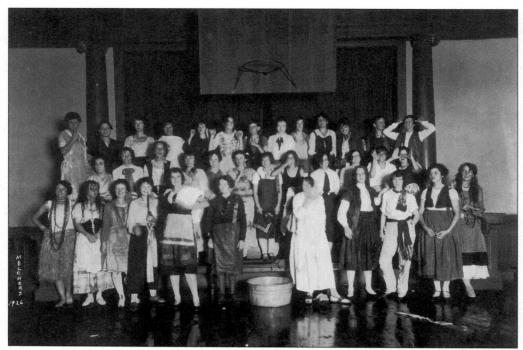

FRESHMAN INITIATION, 1926. Girls jumped into the freshmen initiation with as much enthusiasm as the boys. Campus Humor: Rat Burkett: "Hello, little one. Haven't I seen you some place before?" Little One: "Yes, I used to be a nurse in an insane asylum." (Courtesy of Special Collections, College of Charleston Library, Charleston, SC.)

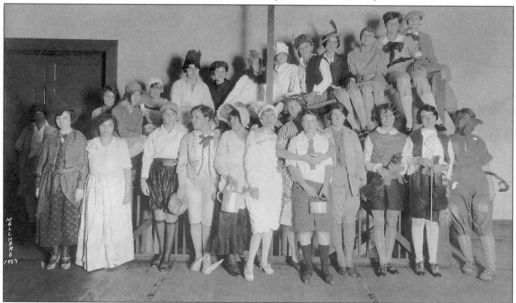

FRESHMAN INITIATION, 1927. The tamest initiations consisted of making the freshmen wear green as a symbol of their youth and inexperience, but initiations were seldom tame. (Courtesy of Special Collections, College of Charleston Library, Charleston, SC.)

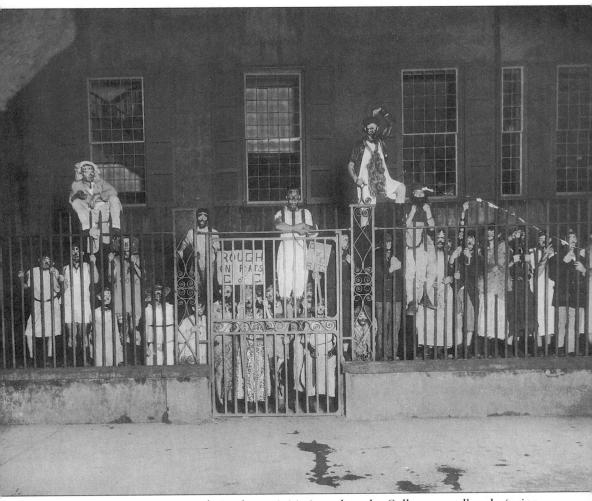

FRESHMAN INITIATION, BOYS, 1924. Freshmen initiation when the College was all-male (prior to 1918) was brutal. The freshmen were required to report to the Cistern, where they were then dunked in the man hole (which still holds 40,000 gallons of water today). Next they had to roll in grease and then in the crushed oyster shells of the walkways. Then they were yoked together by a rope around their necks and paraded down King Street yelling, "I am a rat!" and singing "Hail, Hail, The Gang's All Here!" (Courtesy of Special Collections, College of Charleston Library, Charleston, SC.)

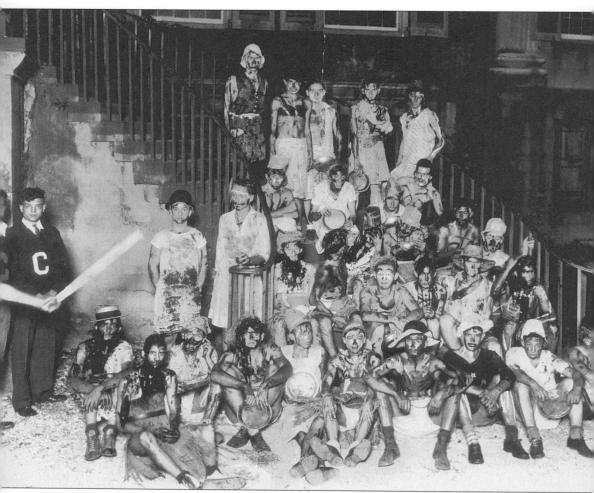

Freshman Initiation, 1930. An alumnus looking back on the initiation wrote, "It inevitably tends to become humiliating and cruel and dangerous, but there are things to be said in its favor. I have known a few men to spend four years at the College without ever once realizing that they could be fools like the rest of us." (Courtesy of Special Collections, College of Charleston Library, Charleston, SC.)

A RAFFISH LAD, 1926.
Early rules read, "students are forbidden to smoke within the College grounds; to use, bring, or have in their possession within the precincts of the College any intoxicating liquors, any firearms, fireworks, explosives, knives, dirks, or deadly weapons; to be guilty of any gaming, profanity, obscenity, drunkenness or any immoral or disorderly conduct." President Randolph had replaced this with a more generalized code of conduct. (Courtesy of Special Collections, College of Charleston Library, Charleston, SC.)

~ Recreation between Classes ~

CLASSROOMS AND LABS, c. 1900. At the time, Max Planck's new Quantum Theory concluded that energy is radiated not constantly but in discrete parcels called "quantums." Sigmund Freud was pioneering psychosomatic medicine. Eastman Kodak's Brownie Box Camera sold for $1. (Courtesy of Special Collections, College of Charleston Library, Charleston, SC.)

TIMELESS CAMPUS HUMOR IN 1926. (Courtesy of Special Collections, College of Charleston Library, Charleston, SC.)

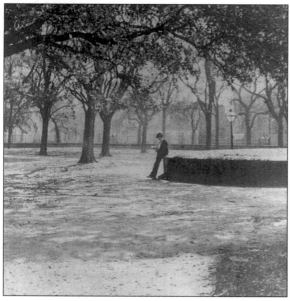

THE CISTERN, C. 1925. At the end of each day, the students all went home, and the campus became a quiet and contemplative place.

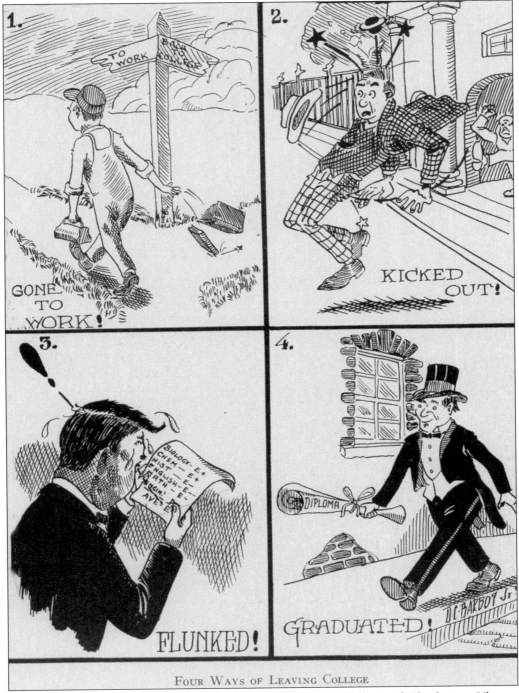

FOUR WAYS OF LEAVING COLLEGE

CAMPUS HUMOR, 1926. (Courtesy of Special Collections, College of Charleston Library, Charleston, SC.)

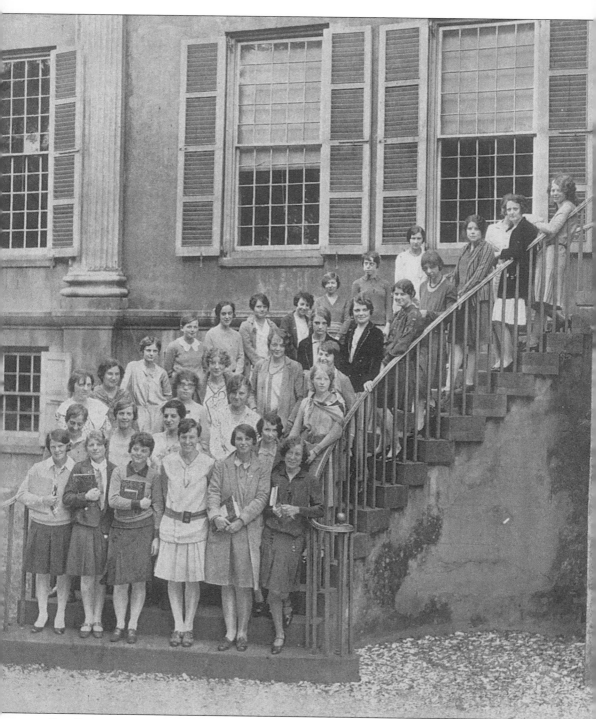

THE FRESHMAN CLASS, 1930. Perhaps because survival of the College did not depend on tuition, professors never hesitated to flunk a student, and the College was always known for its academic rigor. When the Class of 1928 came in as freshmen it had 128 students, but by

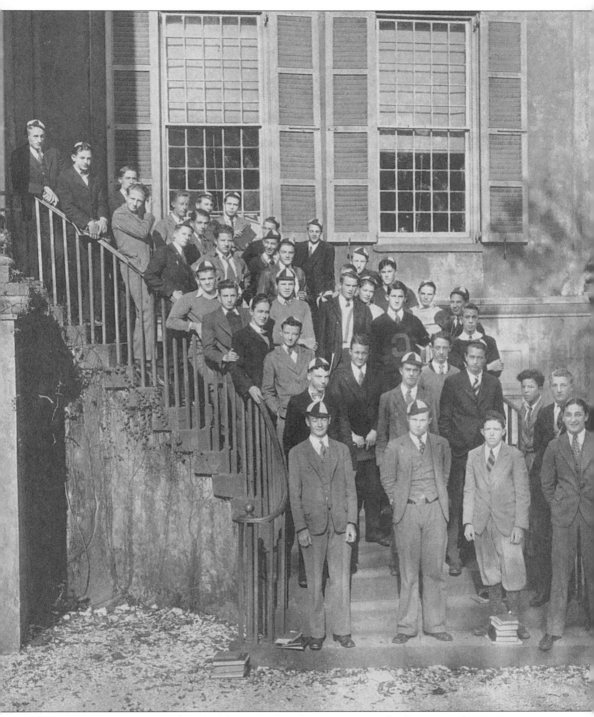

the time they graduated they had been reduced to 32, primarily due to academic attrition. (Courtesy of Special Collections, College of Charleston Library, Charleston, SC.)

THE HONORABLE ROBERT, 1930. The very first College janitor was hired around 1828 at a salary of $800 a year. His duties were to "ring the bell, keep every part of the College clean together with the yard, cut the wood and make the fires in winter, keep the philosophical apparatus clean, and be in constant attendance when not otherwise engaged to do the duties of a messenger." He lived in the Lodge and supplemented his income by keeping a cow, chickens, and goats that roamed the Green. A student petition of 1854 complained that "the presence of the Janitor's Cow in the Campus interferes with the gymnastic exercises and is regarded as a nuisance." Robert came to the College in 1904 and remembered the days when the museum was in Main Building, Egyptian mummies were in the commerce room, a whale skeleton extended from the Spanish room into a rest room, buffalo and ostriches roamed the French room, and monkeys were in the library annex. (Courtesy of Special Collections, College of Charleston Library, Charleston, SC.)

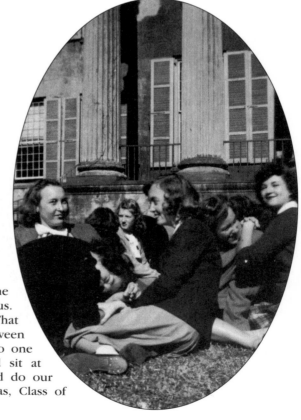

THE CISTERN, 1943. The Cistern was the center of social life on campus. "Everyone always sat on the Cistern. That was the place to sit with friends between classes, have lunch or just relax. No one wanted to go home so we would sit at George's or in a sorority room and do our school work," remembers Jane Lucas, Class of 1946. (Courtesy of Jane Thornhill.)

HUMOR OF 1925. Yes, parking has always been a problem in Charleston. (Courtesy of Special Collections, College of Charleston Library, Charleston, SC.)

HUMOR, 1939. This "rat-hatted" freshman is trying to help the co-ed along toward her "M.R.S. degree." The business of socializing the freshmen into college mores was taken quite seriously. In the 1920s, the upperclassmen held, with administration approval, a "Kangaroo Court" to deal with freshman misbehavior. (Courtesy of Special Collections, College of Charleston Library, Charleston, SC.)

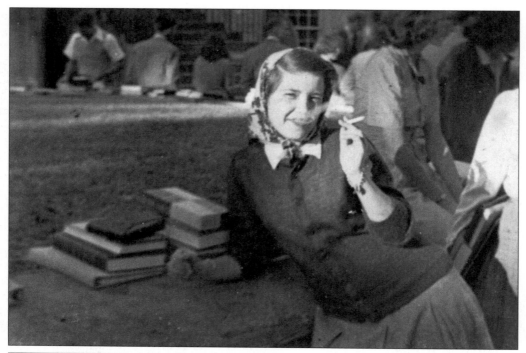

JANE LUCAS, 1942. "Gosh is that really me?" Lucas asked. "I can't believe I smoked. How disgusting! And the only reason I did it was because everyone else was! Smoking was THE thing to do; you never had to hide it." (Courtesy of Jane Thornhill.)

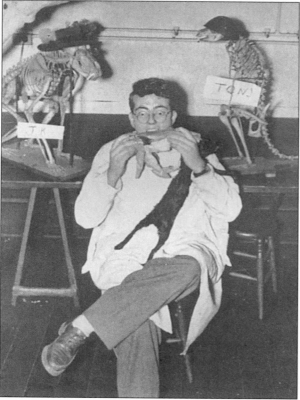

GAGGING AROUND. A gag photograph shows a student eating a lab dissection animal. This photo was taken in 1943, but with the animal skeletons, it is reminiscent of the days when the Charleston Museum was spread across the top floor of Main Building. (Courtesy of Special Collections, College of Charleston Library, Charleston, SC.)

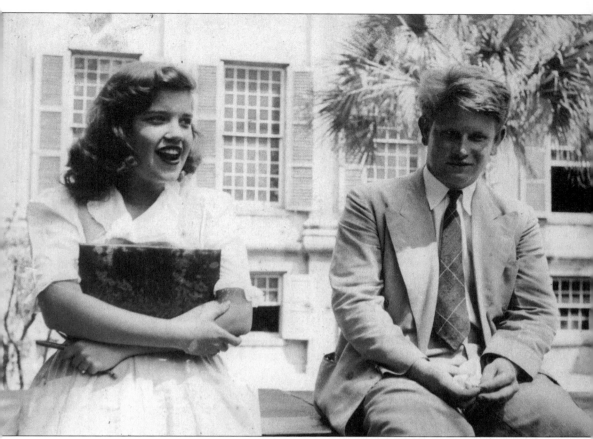

JANE LUCAS AND SAM BODDIE, 1944. Life was not all lounging on the Cistern during the war years. Lucas remembers taking a bus to the Stark Hospital in North Charleston on Friday nights with her girlfriends to entertain wounded soldiers. "That was where many of the wounded men were sent, and we would go up there to keep them company and get their minds off the pain," she reminisced in the year 2000. (Courtesy of Jane Thornhill.)

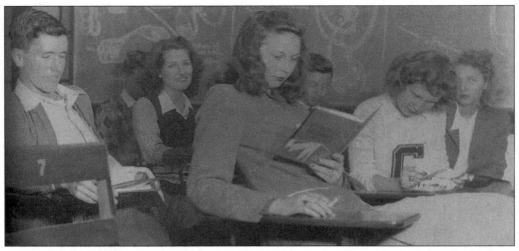

A Posed Classroom Photo in 1946. The girl is holding a book upside down, and it looks as though she is holding a cigarette. Smoking was never allowed in the classroom, but it is said that in order to get out of English professor William Abbot's class, students would tap cigarettes on their desks. Abbot was such a chain-smoker that the hunger would come over him, and he'd dismiss class early. (Courtesy of Special Collections, College of Charleston Library, Charleston, SC.)

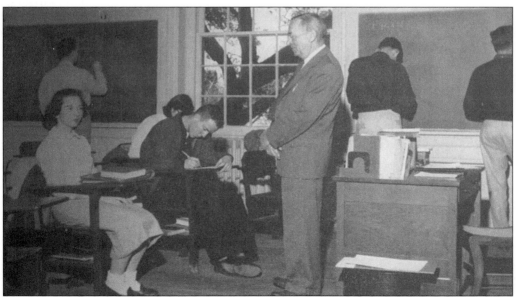

A Classroom Scene, 1957. Pictured is Professor Robert Coleman, a teacher of math whose course was so tough he was rumored to have flunked his own son. By this time Frank Sinatra was still popular, but Elvis had appeared. The girl is wearing the then-popular Bobby socks. (Courtesy of Special Collections, College of Charleston Library, Charleston, SC.)

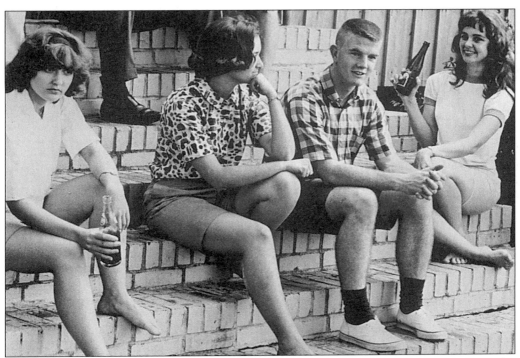

CLASSIC FASHIONS OF 1965. The boy with the crew cut and the madras shirt could be in the television sit-com *Dobie Gillis*. (Courtesy of Special Collections, College of Charleston Library, Charleston, SC.)

CO-ED, 1965. The term "co-ed" was used right from the beginning in 1918 and only went out of fashion in the late 1960s. The student pictured here is in a science lab in Main Building wearing that essential Villager blouse. All classes were still held there until 1970, when the College became a state institution and Main was renamed Randolph. (Courtesy of Special Collections, College of Charleston Library, Charleston, SC.)

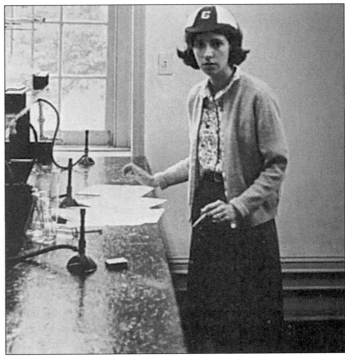

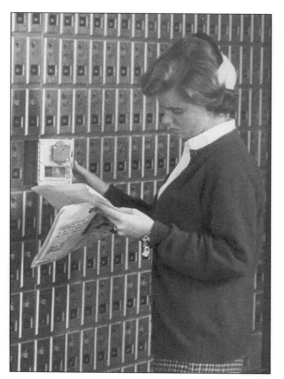

AT HER MAILBOX, 1965. This picture shows a girl checking her mail from her box in a new dorm. She is wearing a freshman beanie in the prevailing fashion of folding it and pinning it to her hair. (Courtesy of Special Collections, College of Charleston Library, Charleston, SC.)

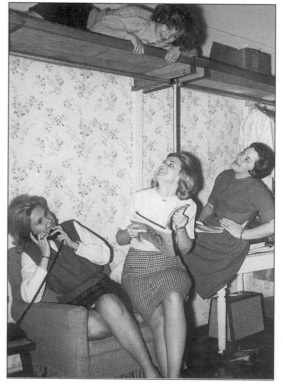

DORM LIFE. The construction of dorms made possible the admission of out-of-town students, and the growth of the College has continued to this day. (Courtesy of Special Collections, College of Charleston Library, Charleston, SC.)

Three

CAMPUS VIEWS

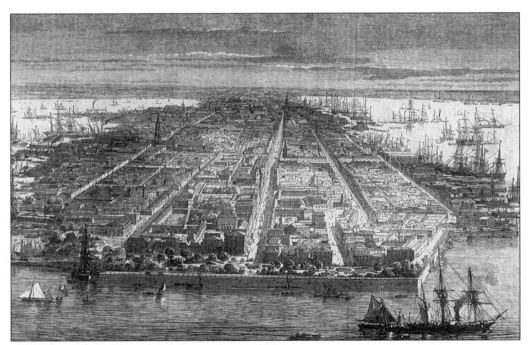

A BIRD'S-EYE VIEW OF CHARLESTON, 1850s. While there are inaccuracies in the woodcut, this view nonetheless gives a feel for the commerce and crowding of the city in the 1850s. Rice and lumber boats went to the left side of the peninsula, major shipping to the right. (Courtesy of Special Collections, College of Charleston Library, Charleston, SC.)

THE BATTERY, 1930. Because the College of Charleston was a city college and most of the students lived at home, it is impossible to separate campus life from that of the city. The Battery has always been a popular Charleston attraction for tourists and lovers. Campus Humor, 1930: "I heard that the dean of women is going to try to stop necking." "I should think that she would, a woman of her age." Campus Humor: "Say, did you grab my daughter by the foot?" "Oh, no, sir! Far from it!" (Courtesy of Special Collections, College of Charleston Library, Charleston, SC.)

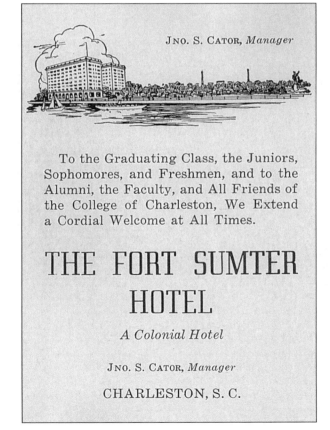

JNO. S. CATOR, *Manager*

To the Graduating Class, the Juniors, Sophomores, and Freshmen, and to the Alumni, the Faculty, and All Friends of the College of Charleston, We Extend a Cordial Welcome at All Times.

THE FORT SUMTER HOTEL

A Colonial Hotel

JNO. S. CATOR, *Manager*

CHARLESTON, S. C.

THE FORT SUMTER HOTEL. Built in 1925, the Fort Sumter Hotel remained one of the swanky Charleston hotels for many years and was a popular spot for college social events. It was here during World War II that a young naval officer named John Kennedy had a regular tryst with the ex-wife of an Austrian diplomat, drawing the attention of the FBI and getting Kennedy sent to the Pacific for PT Boat duty. (Courtesy of Special Collections, College of Charleston Library, Charleston, SC.)

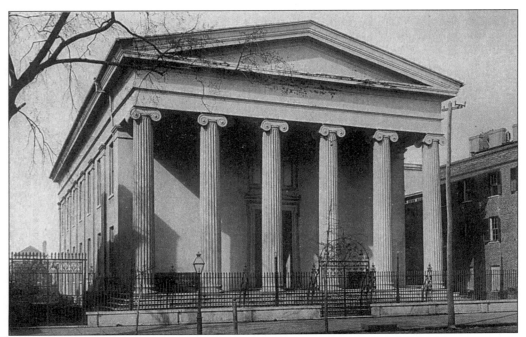

HIBERNIAN HALL. This fine building was built in 1840 for an Irish Fraternal society. Early College commencements were held here, and it was used for College social events up into the 1950s. (Courtesy of Special Collections, College of Charleston Library, Charleston, SC.)

CENTRAL MARKET WITH BUZZARDS, *C.* **1900.** Farmers brought their produce into the market, and butcher shops threw out their trimmings. The streets were cleaned by "Charleston eagles." A policeman in a Keystone Cops–type uniform can be seen in the archway. Charleston was compared to Singapore as a wide-open sailor's town with liquor, gambling, and prostitution. The area between King and Market, and especially West Street, was filled with brothels. When John Grace was mayor in 1911, reportedly the chief of police's brother was a bootlegger and another one sat on a grand jury probing liquor law violations. (Courtesy of Special Collections, College of Charleston Library, Charleston, SC.)

St. John Hotel

MODERATE RATES
FREE PARKING

Mrs. J. W. Ivey, Vice-President
M. Otis Spyers, Manager

CHARLESTON, S. C.

Meeting Street at Queen

THE ST. JOHNS HOTEL. The St. John's Hotel, designed by famous architect Robert Mills, had scaffolding up for renovations in the 1950s, but when the whole north side fell into Queen Street, they had to rebuild. They kept the original facade and named it the Mills House. After the repeal of Prohibition, liquor by the drink was still illegal in South Carolina. The hotels, liquor, and gambling were key to bringing tourists into Charleston's depressed economy. In the 1940s Governor Maybank was so appalled by Charleston's open consumption of alcohol that he threatened to send police down to take care of the problem. The mayor of Charleston at the time, "Tunker" Lockwood, called a press conference and stated flatly, "The State of South Carolina may be dry, but Charleston will remain wet." (Courtesy of Special Collections, College of Charleston Library, Charleston, SC.)

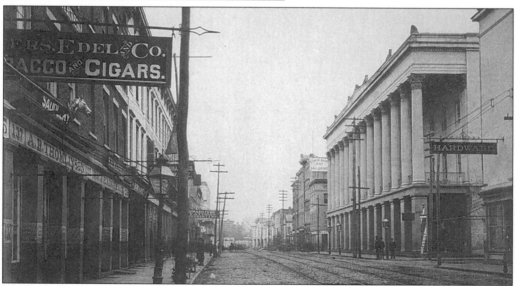

THE CHARLESTON HOTEL. The magnificent Greek Revival-style Charleston Hotel was built in 1838, burned immediately, and then was rebuilt in 1839. A 19th-century visitor said it was "Large columns outside—tough steak inside." It remained a fancy hotel, one of the social spots for student events, even past the end of World War II. In one of the city's great desecrations, it was demolished in 1960 for a typical motel of the era. (Courtesy of *Charleston South Carolina in 1883*, Arthur Mazyck, the Heliotype Printing Co., Boston.)

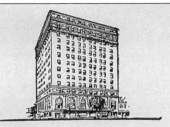
THE FRANCIS MARION HOTEL. Built in 1924 to capitalize on the growing tourist trade, the Francis Marion was one of the ritzy hotels in Charleston. Many student events took place there, as there were no facilities on the College campus. The top floor was in fact the 13th, but never called that of course, being the "roof" or the "penthouse" instead. Gen. Mark Clark lived there for a time after World War II. (Courtesy of Special Collections, College of Charleston Library, Charleston, SC.)

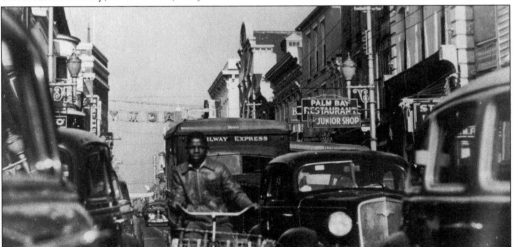

KING STREET, 1940s. The Palm Bay restaurant shown here was a popular dinner spot along with the Normandy, a seafood restaurant. LaBrasca's on Cleveland Street near County Hall was favored by cadets because you could get a beer in a teapot on Sundays if you asked for Russian Tea. College students swore by the hamburgers and pies at the Goody House on Calhoun Street. Henry's in the Market was the "white tablecloth" restaurant always recommended to "out-of-town people." (Courtesy of Special Collections, College of Charleston Library, Charleston, SC.)

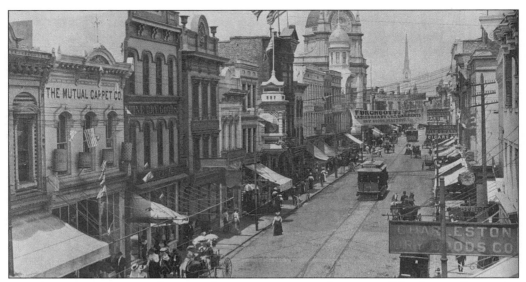

KING STREET. Dominating the scene for many years was the tower of the former Enterprise Bank, which became the Hirsch-Israel Department Store. The tower was later pulled down, but the rest of the building remains. (Courtesy of Special Collections, College of Charleston Library, Charleston, SC.)

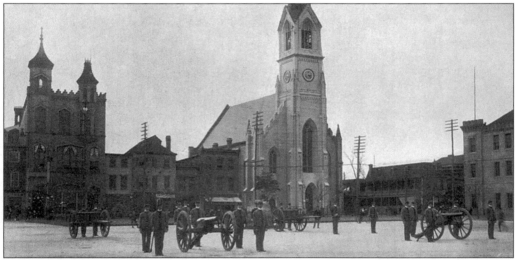

AN ARTILLERY SQUAD ON MARION SQUARE, SOUTH CAROLINA MILITARY ACADEMY, 1902. A corps of cadets was chartered in 1842 to provide the training for an officer class, and the South Carolina Military Academy was born. St. Matthew's German Lutheran Church and the Pythian Castle Hall are visible. In the earliest days of the Citadel, the College of Charleston students were quite envious and demanded a military uniform of their own. The faculty strongly objected, but submitted in 1847 with the proviso that no student had to wear it against his will. The uniform was dark blue with silver buttons and white duck trousers. Weekly drills of the cadet company and marksmanship prizes on the Fourth of July and Washington's birthday became a part of college life. The "College Cadets" did not enter the Civil War as a unit, and the company was not revived after the war. (Courtesy of The Daniel Library, The Citadel, Charleston, SC.)

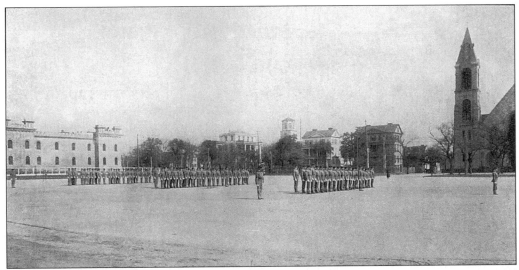

THE CITADEL SQUARE BAPTIST CHURCH, 1901. Marion Square was known as Citadel Green until the 1880s, hence the name for the Baptist church. It was built in a Norman style with a spire that rose 220 feet. This picture shows fabulous mansions that were destroyed for the Strom Thurmond Federal Building. The hall was annihilated to provide parking for the Francis Marion. To the right is a police station that was acquired by the Citadel in 1908 to become Court Hall and demolished for a public library in the 1950s. (Courtesy of The Daniel Library, The Citadel, Charleston, SC.)

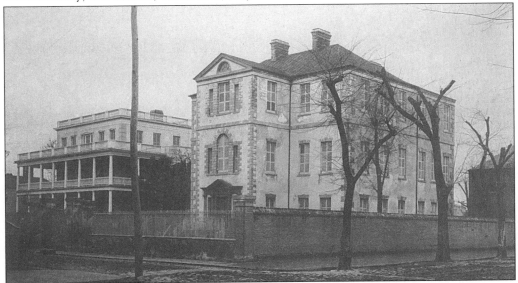

CHARLESTON HIGH SCHOOL. Judge King's mansion at the corner of George and Meeting Streets, once known for glittering balls during race week, was purchased by the city in 1880 for a high school which was moved from Society Street. Shown here around 1883, it was overcrowded with 175 boys. Latin and Greek were taught in this, the only high school in South Carolina with classical studies. This view is looking west on George Street toward the College. The site would later be used for a YMCA and the College gymnasium. (Courtesy of *Charleston South Carolina in 1883*, Arthur Mazyck, the Heliotype Printing Co., Boston.)

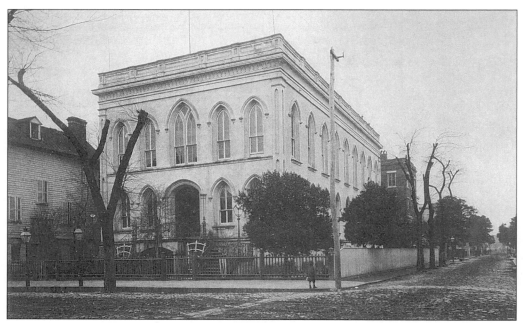

FREUNDSCHAFTSBUND HALL, BUILT *C.* 1870. This German bund was a charitable, self-help, and social society typical of so many in America (Masons, Odd Fellows, etc.) before social welfare. It had a club and billiard and dining rooms on the ground floor and a spacious hall above. It stands at Meeting and George opposite the site of the old high school and later the College gymnasium. (Courtesy of *Charleston South Carolina in 1883*, Arthur Mazyck, the Heliotype Printing Co., Boston.)

THE OLD GYM. While other sports came and went, the College clung tenaciously to basketball and ultimately became a national power under Coach Kresse in the 1980s. Today, their old rivalry with the Citadel is ancient history as the Citadel can barely stay on the court with the Cougars. (Courtesy of Special Collections, College of Charleston Library, Charleston, SC.)

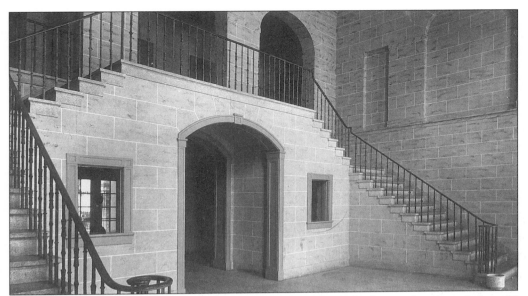

THE STUDENT ACTIVITIES CENTER, 1941. A gymnasium was built on the site of the old Charleston High School due to the influence of Burnet Maybank. Federal largesse was so new then that the building was regarded with awe by all of Charleston. The sign next to the rail fence boasts that it was a PWA project. (Courtesy of Special Collections, College of Charleston Library, Charleston, SC.)

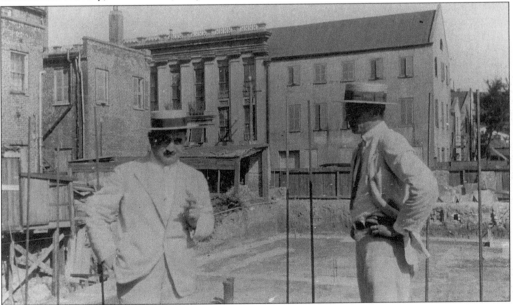

ALBERT SOTTILE, GLORIA THEATER CONSTRUCTION, 1920. Albert Sottile came from Sicily in the 1890s and opened a vaudeville theater, the Victoria (later Victory), on Society Street between King and Meeting. He quickly saw the potential for "moving pictures" and opened the Wonderland on King opposite Hasell Street and the Majestic on King just above George. Here he is shown at the excavation of his flagship Gloria Theater. (Courtesy of Special Collections, College of Charleston Library, Charleston, SC.)

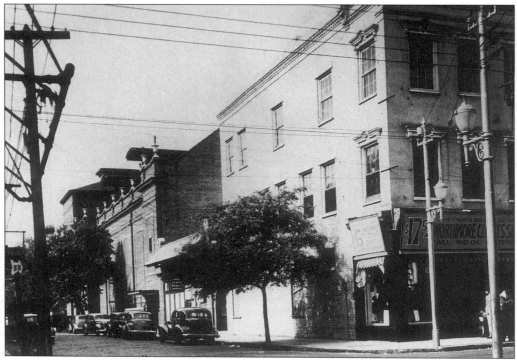

THE GLORIA THEATER, CORNER OF GEORGE AND KING. Albert Sottile's Pastime Amusement ran four theaters in the area of the College—the Victory, the Riviera, the Gloria, and the Garden. The Victory had stage shows. Sottile also ran a small theater called the Majestic that showed "serials," and kids could get in on Saturdays for two milk caps. The Gloria was Sottile's pride and joy. (Courtesy of Special Collections, College of Charleston Library, Charleston, SC.)

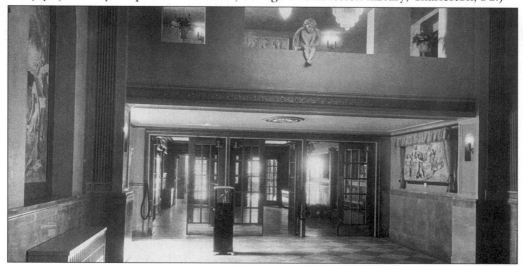

THE GLORIA THEATER, INTERIOR. An opulent movie palace of the era, the theater has archways, pilasters, friezes with the Greek key design, and a saucer ceiling with stars. Before air conditioning it was cooled by big fans blowing across blocks of ice. (Courtesy of Special Collections, College of Charleston Library, Charleston, SC.)

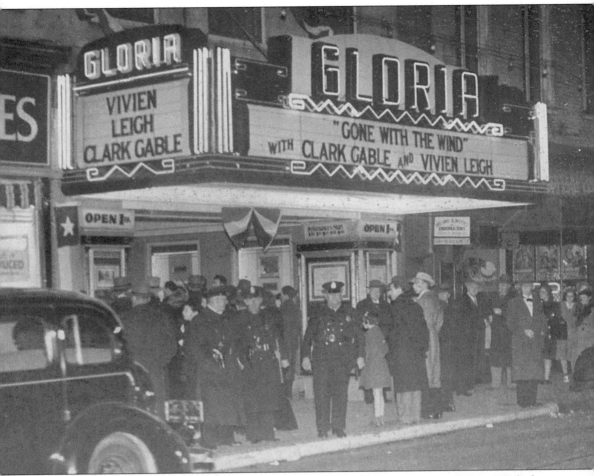

THE GLORIA THEATER. The Gloria was the venue for the Charleston premier of *Gone With the Wind,* with most of the cast present and staying at the Villa Margherita. (Courtesy of Special Collections, College of Charleston Archives, Charleston, SC.)

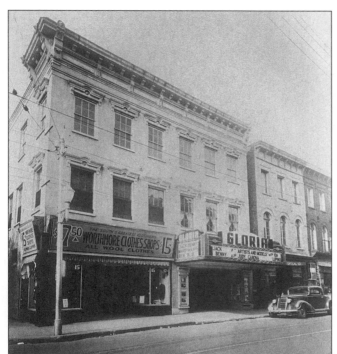

THE GLORIA THEATER. In an age when the typical American was not affluent, movies and eating out were popular entertainment. The 1912 admission to the Sottile theater was 5¢. (Courtesy of Special Collections, College of Charleston Library, Charleston, SC.)

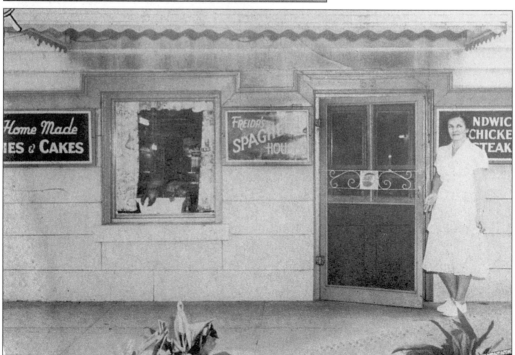

FREIDA'S, 1956. Freida's Spaghetti House was a popular restaurant on George Street on the site of the current parking garage. Across the street was Laurey's Pool Hall and Bowling Alley. (Courtesy of Special Collections, College of Charleston Library, Charleston, SC.)

PLANTER BARNARD ELLIOTT'S GEORGIAN-STYLE HOUSE, 58 GEORGE STREET, BUILT *c.* **1803.** In 1952, it became apartments; in 1971 it was bought and restored by the College under the direction of Albert Simons. For many years, George Stamos' College Recreation, a popular student haunt, was in the basement. George always advertised in the *Comet*; the ads show the evolution of his fruit stand to the College Recreation. (Courtesy of Special Collections, College of Charleston Library, Charleston, SC.)

THE COLLEGE RECREATION

HOT DOGS
SANDWICHES
COLD DRINKS
CAKES
CIGARETTES
CANDY

"Meet Me At George's"

GEORGE STAMOS' COLLEGE RECREATION. This snack bar on the corner of George and St. Philip was a popular place for students to meet and eat. There were tables and pinball machines in the back and students often did their homework there rather than go home. (Courtesy of Special Collections, College of Charleston Library, Charleston, SC.)

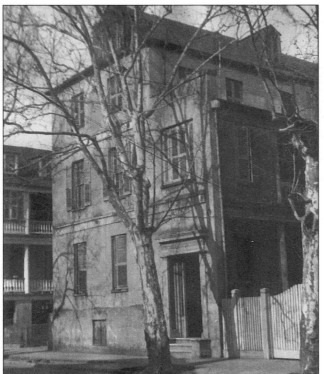

THE GRAVES HOUSE, 36 COMING STREET, BUILT C. 1842. Coming Street is named for John Coming, whose heirs sold property at the center of the campus for "Free School Lands," a project that predated the College but never came to fruition. This three-story brick single house was built by the wealthy planter Charles Graves on a leased plot of the Glebe lands. (Courtesy of Special Collections, College of Charleston Library, Charleston, SC.)

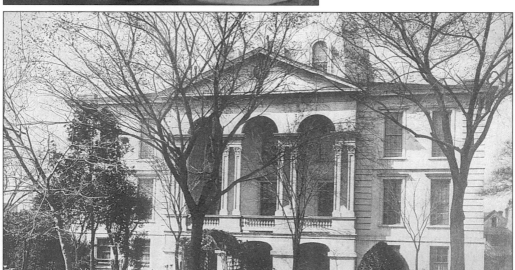

MEMMINGER NORMAL SCHOOL, BUILT C. 1858. C.G. Memminger was an orphan fortuitously raised by a rich merchant. Acutely conscious of class differences, he favored "bringing together the children of rich and poor" in the same school. In the 1850s he was active in promoting a public school system, and this beautiful building on St. Philip Street was the first free public school in the state. Run as a Normal School—a teacher training school—it ✱ was <u>for girls only</u> until its destruction in 1950. (Courtesy of *Charleston South Carolina in 1883*, Arthur Mazyck, the Heliotype Printing Co., Boston.)

(handwritten annotation:) 1941-1942 SCHOOL YEAR

70

✱NOT EXACTLY TRUE. FOR ONE YEAR ONLY, BOTH BOYS AND GIRLS ATTENDING THE TEMPORARY "NATHAN'S JUNIOR HIGH" (A CONVERTED WENTWORTH ST. MANSION BACKING ONTO THE MEMMINGER AUDITORIUM) ALSO ATTENDED THEIR ART & SCIENCE CLASSES (THAT I KNOW OF) IN THE MEMMINGER SCHOOL, WHICH ALSO SUPPLIED LUNCHES.

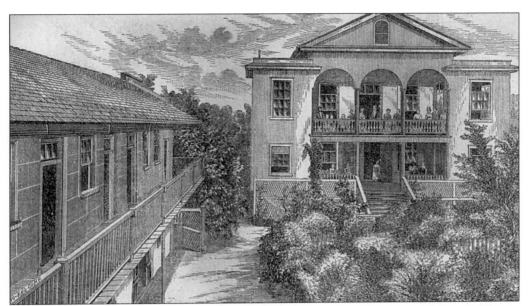

MISS KELLY'S SCHOOL, 50 ST. PHILIP STREET. In 1870, Miss Etta Kelly founded the Charleston Female Seminary in a fine building she constructed on St. Philip Street. It boasted "the new American school desks and settees (Munger's patent with Allen's opera folding-seat patent), a style unrivaled in comfort and elegance of appearance." Miss Kelly took boarders, and being a big believer in *mens sana in corpore sano*, required calisthenics. (Courtesy of *Guide to Charleston Illustrated*, compiled by Arthur Mazyck, *c.* 1875.)

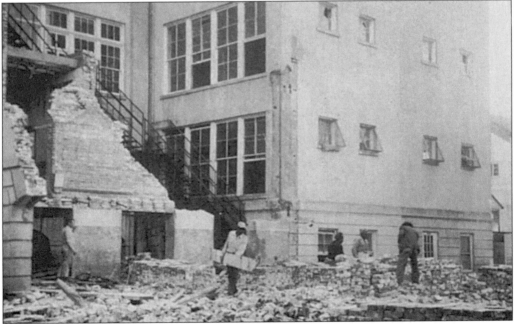

BENNETT SCHOOL, 1960. This public elementary school stood directly across the street from the Lodge until it was torn down for the Craig Dorm and cafeteria. (Courtesy of Special Collections, College of Charleston Library, Charleston, SC.)

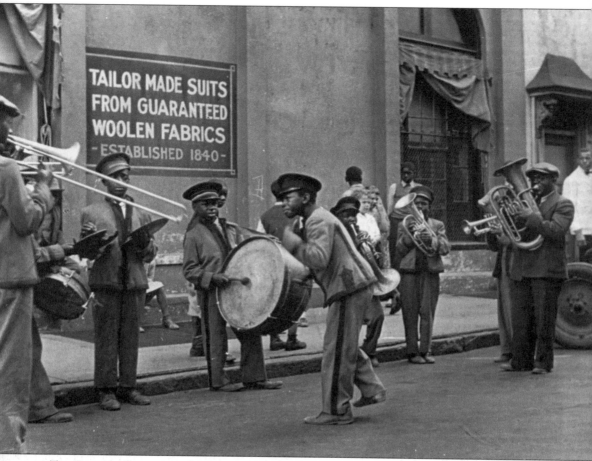

THE JENKINS ORPHANAGE BAND, *C.* **1920.** Dressed in cast-off Citadel uniforms, the Jenkins Orphanage Band was a familiar sight in Charleston as they played on street corners for money dropped into a hat—a primary source of the support of their home with its 500–600 children. The Reverend D.J. Jenkins founded the orphanage in 1891 in the Old Marine Hospital at 20 Franklin Street. With the international attention brought by "The Charleston," they traveled abroad several times and toured the East Coast until the 1950s. Many of their musicians went on to play with Duke Ellington and Count Basie. (Courtesy of Special Collections, College of Charleston Library, Charleston, SC.)

COMING UPON THE BAND PLAYING ON THE STREET WAS AN ABSOLUTE
WONDER OF MY CHILDHOOD.
THESE WERE USUALLY CHANCE ENCOUNTERS, BUT WE AND THEY
ALWAYS SHOWED UP AT THE AZALEA FESTIVAL

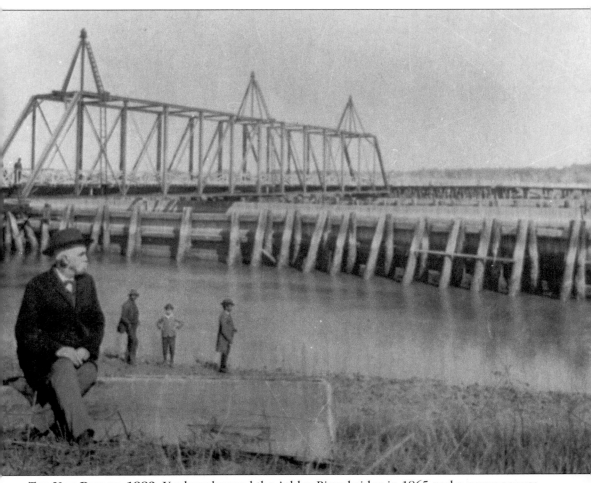

THE NEW BRIDGE, 1889. Yankees burned the Ashley River bridge in 1865 and a new one was not built until 1889. In that year, the Charleston Bridge Co. erected a wooden toll drawbridge that linked the city to Saint Andrew's Parish. The city bought out the company and built a concrete one in 1926. Automobile traffic poured into Boundary Street (Calhoun) and with the growth of the hospitals ultimately wrecked its residential nature. (Courtesy of Special Collections, College of Charleston Library, Charleston, SC.)

STUDENTS IN OFFICE, 1947. The College was basically still Main Building and run with a staff of four secretaries and a registrar. This was a major increase in staff as President Randolph had operated from 1897 to 1914 without a stenographer. (Courtesy of Special Collections, College of Charleston Library, Charleston, SC.)

CALHOUN STREET, No. 167. Rosa and Carlo Mauro lived at 167 Calhoun Street until it was torn down for Maybank Hall. This photo shows the residential character of Calhoun and a glimpse of the Orphan House and the Francis Marion Hotel. (Courtesy of Special Collections, College of Charleston Library, Charleston, SC.)

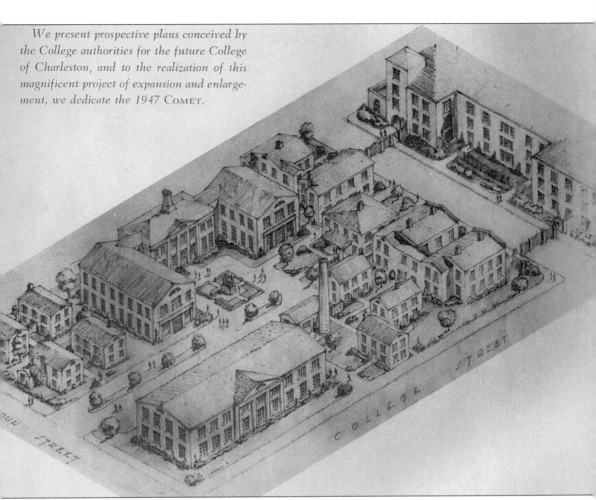

FUTURE VISION, 1947. Just after World War II, Albert Simons, a prominent Charleston architect, projected the future of the College of Charleston. None of these buildings were ever constructed in the fashion he envisioned. The building in the lower right became the Robert Scott Small Library. The drawing does show College Street when it was still open to traffic. (Courtesy of Special Collections, College of Charleston Library, Charleston, SC.)

THE BRITH SHALOM SYNAGOGUE, BUILT C. 1870. Pictured here in 1917, this Orthodox synagogue was known as "Big Shul" to distinguish it from "Little Shul," Beth Israel. Brith Shalom stood on St. Philip Street until it was destroyed for the Simons Art Center. The area of St. Philip, Coming, Warren, and Radcliffe Streets was largely a Jewish neighborhood. (Courtesy of Special Collections, College of Charleston Library, Charleston, SC.)

THE JEWISH COMMUNITY CENTER. Along with Brith Shalom, this building stood on St. Philip Street until it was demolished for Simons Art Center. (Courtesy of Special Collections, College of Charleston Library, Charleston, SC.)

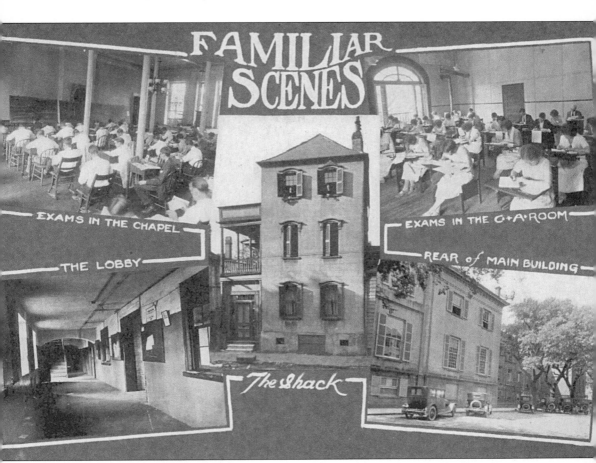

FAMILIAR SCENES

EXAMS IN THE CHAPEL

EXAMS IN THE C+A ROOM

THE LOBBY

REAR of MAIN BUILDING

The Shack

ON CAMPUS, 1925. President Randolph was anxious to increase enrollment by bringing in students from out of town. In 1901, a house at 4 Green Street was purchased for a dormitory and came to be called "the Shack." The residents formed the Shack Club, whose motto in 1917 was "Drink, smoke, and be merry for tomorrow you may get shot." America had entered World War I on April 6. (Courtesy of Special Collections, College of Charleston Library, Charleston, SC.)

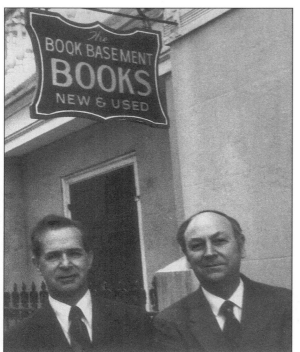

BOOK BASEMENT (1946–71), 9 COLLEGE STREET, BUILT *C*. 1835. John Zeigler (right), a Citadel grad, ran a bookstore on the corner of College and Green Streets in the basement of an aunt's house so "it would be okay if we didn't make the rent." His partner, Edward Peacock (left), was a great friend of Carson McCullers, so they opened on her birthday, February 18, 1946. There were few bookstores at the time and this one, right in the heart of the campus, was an intellectual hub in Charleston. It closed in 1971, when the College of Charleston bought the entire block. (Courtesy of John Zeigler.)

IT WAS JOHN WHO SOLD ME THE COLLECTED WORKS OF YEATS AND OF AUDEN WHEN I WAS ON AIR FORCE LEAVE FROM SYRACUSE IN 1952. (I BELIEVE TIM HAS THEM NOW.)

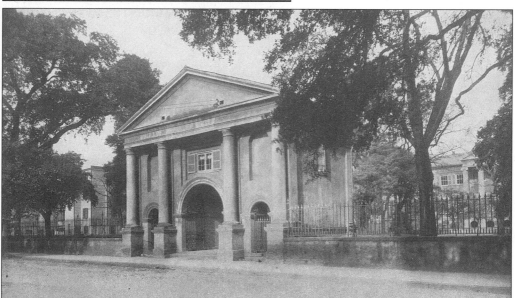

THE LODGE, 1930. The Porter's Lodge on George Street was built in 1850 along with the improvements to Main Building. Col. Edward B. White, architect of the Customs House, designed it in Greek Revival style with triple arches and Doric columns. It housed a fire engine during the War between the States. The engine was horse-drawn, of course, and notches were cut in the walls to allow for the shafts. These still remain. Later the Lodge became a meeting place for male students only. (Courtesy of Special Collections, College of Charleston Library, Charleston, SC.)

UPSTAIRS IN THE LODGE, ABOVE, AT A NIGHT-TIME MEETING OF THE CHRESTOMATHS, I PRESENTED, ORALLY, A PAPER ON T.S. ELIOT'S "THE HOLLOW MEN". GEORGE RABB, WHO LATER RAN THE BROOKFIELD ZOO, HAD THE KEY TO THE PORTER'S LODGE. IMPRESSIVE!

SOUTH PORTICO THROUGH PI KAPPA PHI GATE. Pi Kappa Phi was founded at the College in 1904. It donated the gate in 1929 and the clock at the top of Randolph Hall in 1956. Dan Ravenel (Class of 1972) was a member and recalls as a pledge constantly scrubbing and waxing the parquet flooring in the frat house on Green and Coming Streets. The actives and pledges engaged in endless rounds of kidnapping each other. (Courtesy of Special Collections, College of Charleston Library, Charleston, SC.)

THE CISTERN, 1930. Rainwater ran off the roof of Main Building and flooded its basement, necessitating the building of the Cistern in 1857. It was the source of water for the neighborhood and still holds water today. (Courtesy of Special Collections, College of Charleston Library, Charleston, SC.)

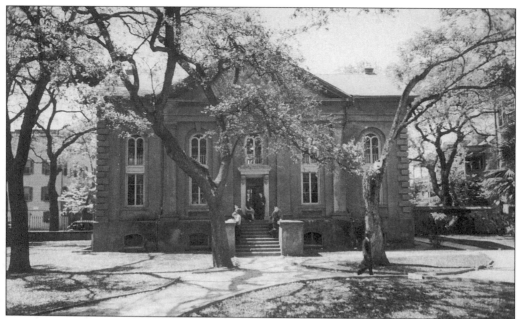

STUDENTS ON THE STEPS OF TOWELL LIBRARY. Library humor, 1931: Dick: "Give me a sentence with the word 'diadem.'" Trap: "People who drive onto railroad crossings while 'binding' diadem sight quicker than those who stop, look, and listen." (Courtesy of Special Collections, College of Charleston Library, Charleston, SC.)

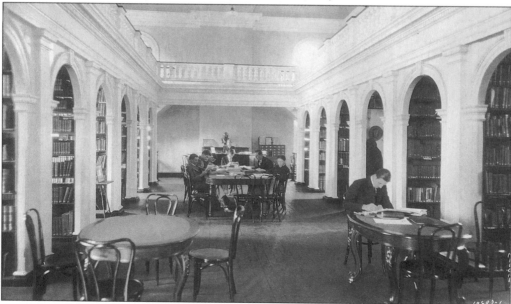

TOWELL LIBRARY, 1965. The old card catalogues are still visible in the picture. The first catalogue of the collection was made in 1892. There were no computers in libraries in 1965, so the cards were typed on typewriters. Subject headings were typed in red and title headings were in black. (Courtesy of Special Collections, College of Charleston Library, Charleston, SC.)

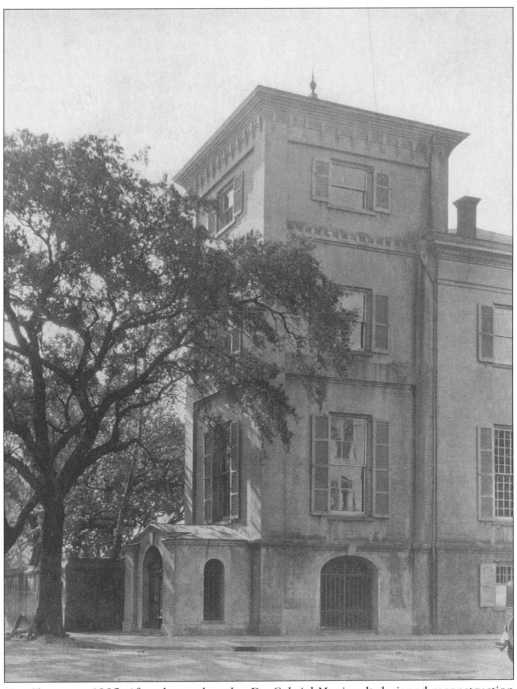

NEW TOWER, C. 1925. After the earthquake, Dr. Gabriel Manigault designed reconstruction of the east wing of Main Building, including a new tower that would give public access to the museum on the third floor without disturbing the classroom floors. The street appears to be dirt, and Greenway was open to traffic. (Courtesy of Special Collections, College of Charleston Library, Charleston, SC.)

ONCE, MARIAN WALLACE AND I SNEAKED INTO THE TOP OF THE TOWER 81 TO HAVE A LOOK AROUND. I WAS LOTS MORE SCARED THAN SHE WAS! (SHE WAS 2 YEARS OLDER.)

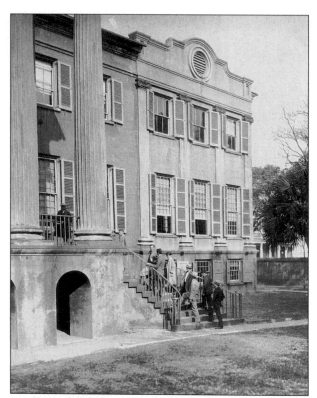

MAIN BUILDING, 1926–27. These dapper young men are dressed in some very stylish hats. Lyendecker's beautifully painted ads for Arrow Collars & Shirts created an ideal of the handsome college man. Popular songs were "Bye Bye, Blackbird," and "When the Red Red Robin Comes Bob, Bob, Bobbin' Along." The first woman swam the English Channel, and Lindbergh flew the Atlantic. (Courtesy of Special Collections, College of Charleston Library, Charleston, SC.)

"LET IT SNOW, LET IT SNOW, LET IT SNOW," c. 1955. Yes, once in a 'coon's age it does snow in Charleston, as seen in this photograph on the steps of Randolph Hall. (Courtesy of Special Collections, College of Charleston Library, Charleston, SC.)

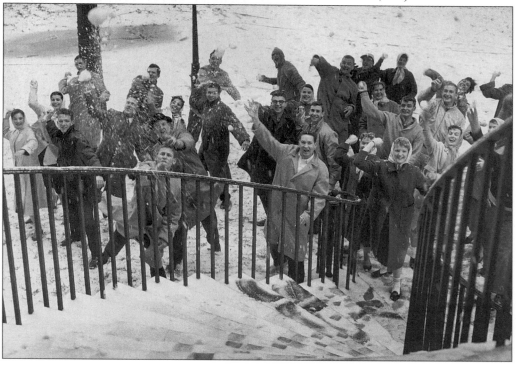

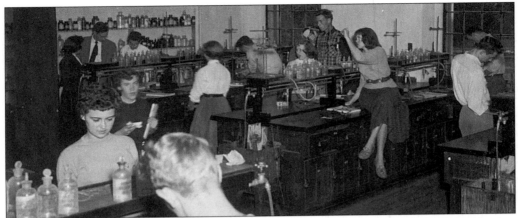

CHEMISTRY LAB, 1955. In that year, the science faculty were Charles Askey, M.S., physics; Evan Porter, M.S., biology; Waldemar Melchert Walter, Ph.D., biology; and Edward Emerson Towell, Ph.D., chemistry. The library was later named for Towell. A full professor's salary at this time was around $5,000. (Courtesy of Special Collections, College of Charleston Library, Charleston, SC.)

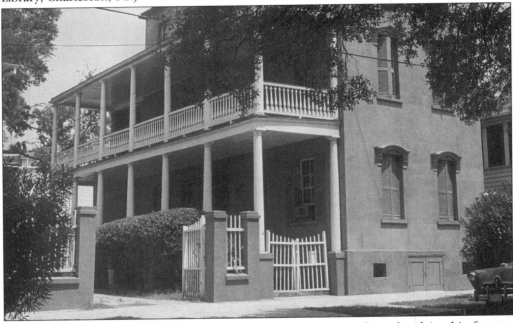

THE SHACK, 4 GREEN STREET. The handful of out-of-town students lived in this famous "shack." It was heated by fireplaces, and Prof. Robert H. Coleman remembered as a student nailing a shoe to the mantel. "It was just the right spot and height so that I could lean back in my chair and put my foot in the shoe which the fire kept warm at all times." The first dormitory for women was opened here in 1960. Ten freshman women lived there "supervised" by a housemother, Mrs. Ludie Johnson. They were served by a cook and a maid until the cafeteria was constructed in 1961. Their presence created great excitement, and President Grice observed, "There have been more male students on the Green Street campus during the past three days than at any other time in the history of the College." (Courtesy of Special Collections, College of Charleston Library, Charleston, SC.)

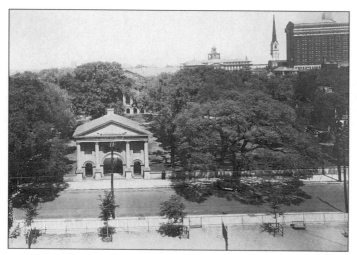

AN AERIAL VIEW OF PORTER'S LODGE. This view of the campus shows the Francis Marion Hotel and the Orphan House. In the foreground is the yard of Bennett School. It was at this time that space on the college campus was so limited that clubs, like the Pre-med, met in the Lodge. (Courtesy of Special Collections, College of Charleston Library, Charleston, SC.)

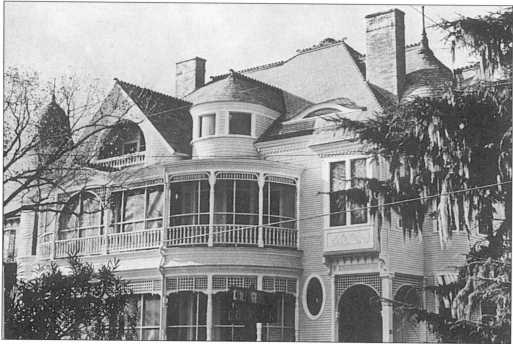

THE UPPER FLOORS OF THE WILSON-SOTTILE HOUSE, 11 COLLEGE STREET, C. 1891. Samuel Wilson was the wealthy owner of the Charleston Tea Pot, a tea and grocery shop, and president of the Dime Savings Bank, the Charleston Bridge Company, and the New Charleston Hotel Company. He was also manager of the Charleston Consolidated Railway, Gas and Electric Company. He constructed this Victorian mansion, which on his death in 1912 went to the Sottiles and then the College in 1964. In the yard of the house stands an enormous evergreen tree that became the first electrically lighted outdoor Christmas tree in Charleston. In 1921, Mrs. Albert Sotille began an annual tradition by hanging oversized, shaped lights donated by the Huger Street fire station and playing Christmas carols over a loudspeaker. (Courtesy of Special Collections, College of Charleston Library, Charleston, SC.)

THE KNOX-LESESNE HOUSE, 14 GREEN WAY, BUILT *C.* 1846. This exquisite house was nearly demolished for a parking lot. Walter Knox, a carpenter, was able to acquire the property from the College in 1817 during one of its periodic financial crises. His wife, Catherine, built the "Tuscan Villa" of cypress siding, with heart pine sills and studs and a slate roof, and lived there the rest of her life. From 1870 to 1881 Albert Oceola Jones, a black Reconstruction politician and clerk of the House of Representatives, lived there with his wife, Estella. It was sold for debt in 1881 and changed hands several times until Willie James Lesesne bought it for $6,000 and in turn sold it in 1961. Mrs. Alberta S. Long sold this house and the next door Wilson-Sottile House to the College in 1964. (Courtesy of Special Collections, College of Charleston Library, Charleston, SC.)

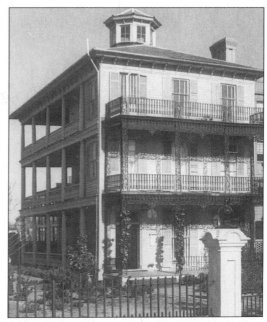

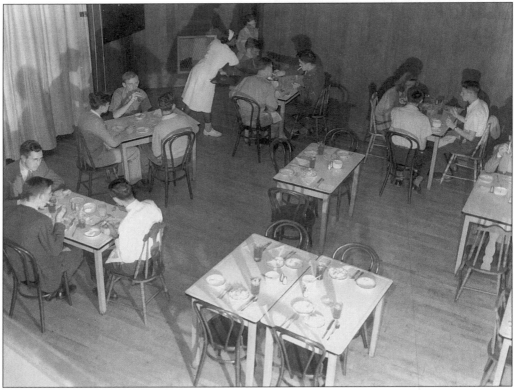

A PRE-CRAIG CAFETERIA PHOTO, *C.* 1950S. The curtain would seem to identify this picture as being taken on the stage of the gym where mid-day meals were served before Craig Cafeteria was built. (Courtesy of Special Collections, College of Charleston Library, Charleston, SC.)

THE CRAIG CAFETERIA, 1965. Craig Dorm (named for Douglas Craig, Class of 1905) was built on the site of the old Bennett School and it had a cafeteria. Right from the beginning the students, of course, did not like the food. In the 1965 *Comet*, the caption read "Freida's anybody?" Freida's Spaghetti House was on the corner of George and St. Philip Streets. Signs outside read, "Home Made Pies & Cakes. Sandwiches, Chicken, Steaks." (Courtesy of Special Collections, College of Charleston Library, Charleston, SC.)

Four

SPORTS

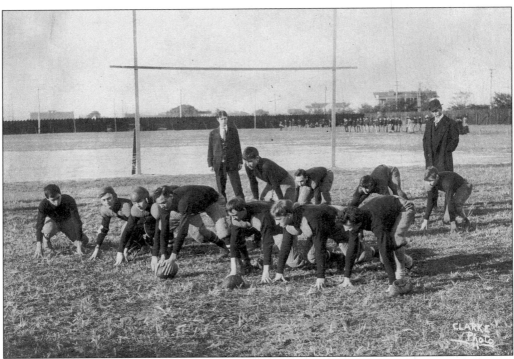

COLLEGE OF CHARLESTON FOOTBALL TEAM, 1900. Football began in 1869 in the Northeastern colleges, and by 1900 had become a national sport. Only one player is wearing a helmet, and it did not do much more than protect the ears. This was an era of deadly injuries. Curiously, Citadel students were still clamoring to be allowed to play football in 1906. (Courtesy of Special Collections, College of Charleston Library, Charleston, SC.)

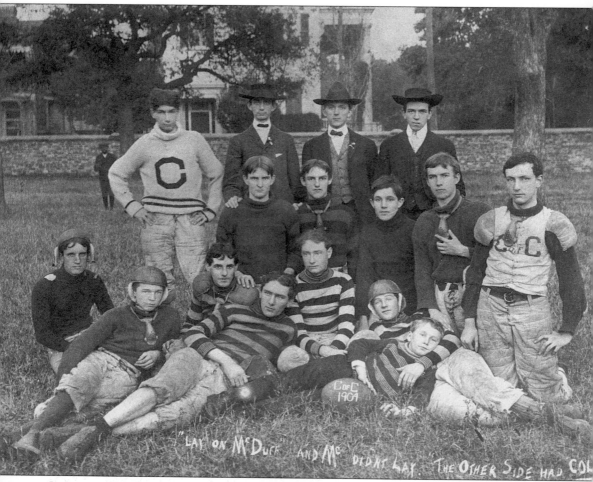

COLLEGE OF CHARLESTON FOOTBALL TEAM, 1904. Note the nose guards around the necks. The College always performed poorly in this sport, which was galling given that the Citadel, which was not very large either, was able to perform well against Carolina, Clemson, and Navy. (Courtesy of Special Collections, College of Charleston Library, Charleston, SC.)

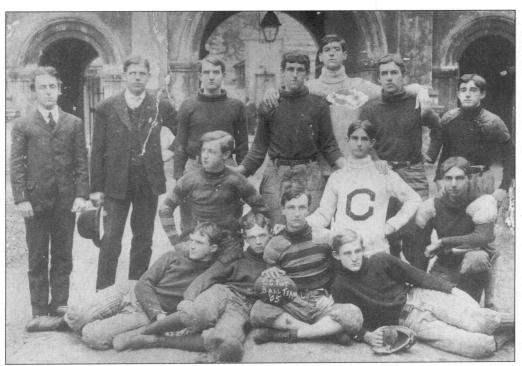

THE FOOTBALL TEAM, 1905. Football was still a kicking game like British rugby. This was the era when multiple injuries caused President Theodore Roosevelt to demand reform. The College had 68 students in this year with the out-of-towners outnumbering Charlestonians for the first time. Harry Mixon, founder of Pi Kappa Phi, is wearing the big letter "C," and his right hand rests on co-founder Simon Fogarty. Mixon's family lived at 90 Broad Street above their grocery. (Courtesy of Special Collections, College of Charleston Library, Charleston, SC.)

THE FOOTBALL TEAM, 1905. New rules allowed the forward pass, and now the game would emphasize the scoring of touchdowns by crossing the goal line. There were still only three downs. This was the first year the Citadel played football, but they did not play the College of Charleston. (Courtesy of Special Collections, College of Charleston Library, Charleston, SC.)

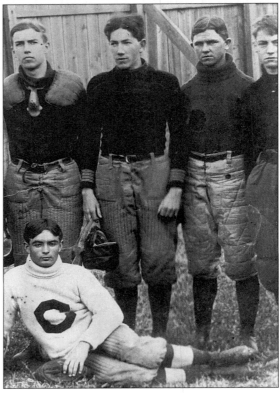

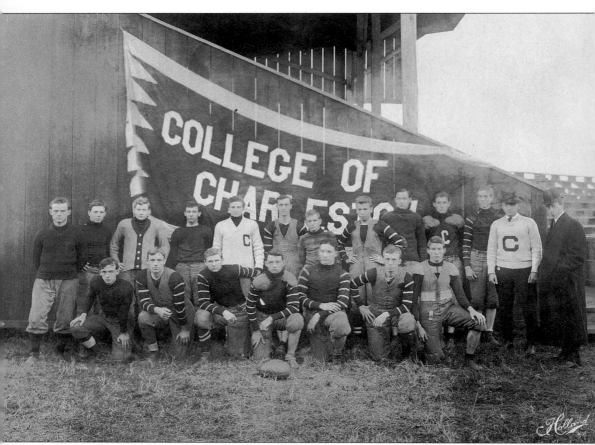

College of Charleston Football Team, 1909. Student enrollment was up to 90, of which 52 came from outside the city. Unfortunately, many of them flunked out, making it as difficult as ever to field a respectable team. In 1910, the College managed to triumph over the Citadel when a player hid the pigskin under his sweater and made 60 yards before being tackled; they followed up by scoring and kicking a goal. But in 1912, the Citadel crushed the College of Charleston, 40-0. (Courtesy of Special Collections, College of Charleston Library, Charleston, SC.)

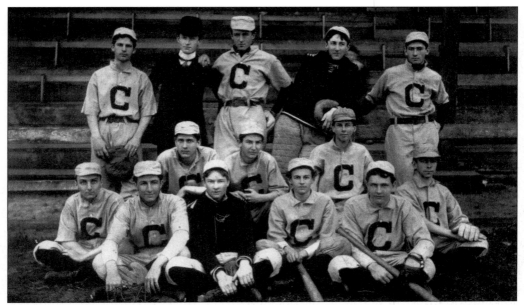

THE BASEBALL TEAM, 1899. You can see the catcher's mask and chest protector, and some of the players have gloves which was considered a bit "sissy" then (or perhaps there was jealousy among those who couldn't afford a glove). The College lost twice to the Citadel that year. (Courtesy of Special Collections, College of Charleston Library, Charleston, SC.)

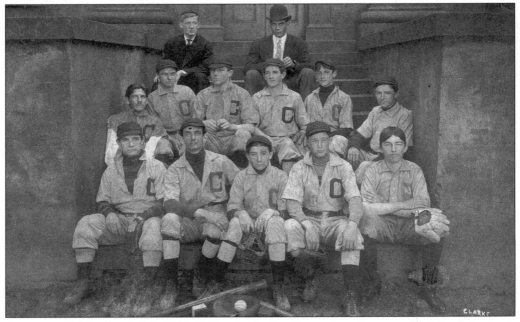

BASEBALL, 1901. Coach J.C. "Chief" Bender is the Native American on the left of the back row. He had been a major league baseball player, but it was not known what team he was on. He then became the baseball coach at the College of Charleston. The manager to his left is wearing pince-nez glasses. (Courtesy of Special Collections, College of Charleston Library, Charleston, SC.)

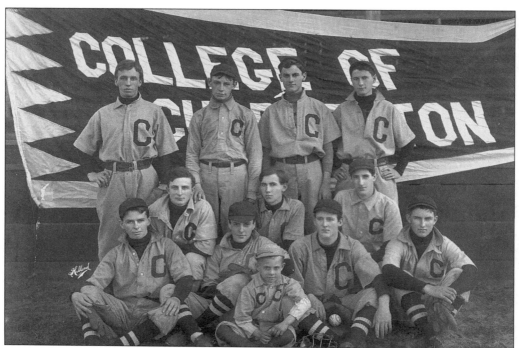

BASEBALL, 1909. The College beat the Citadel that year, and the following year, a pitcher's duel between Cullum for the Citadel and Gaffney for the College of Charleston lasted for 12 scoreless innings before the College of Charleston sent a runner across the plate, winning the game. "A tonic, an exercise, a safety-valve, baseball is second only to Death as a leveler. So long as it remains our national game, America will abide no monarchy, and anarchy will be too slow," said Allen Sangree in 1907. (Courtesy of Special Collections, College of Charleston Archives, Charleston, SC.)

BASEBALL, 1924. Baseball was played at College Park, shared by the Citadel and the College. Cork in the ball had ended the "dead ball" era, and gloves began to be made with the fingers strung together to create a webbed pocket. In 1924, the College beat the Citadel 1-0. After the game the Maroon Flag was "hoisted in token of victory." (Courtesy of Special Collections, College of Charleston Library, Charleston, SC.)

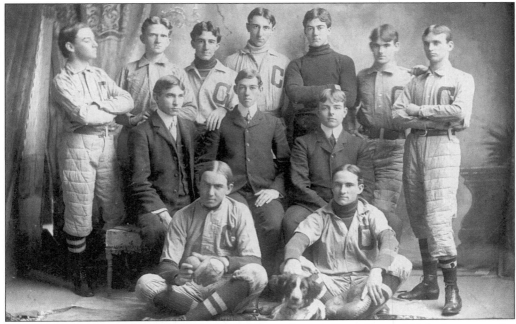

THE BASEBALL TEAM, 1900. This was the year President William Howard Taft threw out the first baseball of the professional season and made the game the "National Pastime." In three years, the first World Series would be held. Diamonds were rough and the ball would take erratic bounces. Gloves were small and designed for protection more than trapping the ball. Frank Merriwell was the baseball hero in *Tip Top Weekly* that sold for 5¢. Philadelphia fans had developed the derisive sound "boo." (Courtesy of Special Collections, College of Charleston Library, Charleston, SC.)

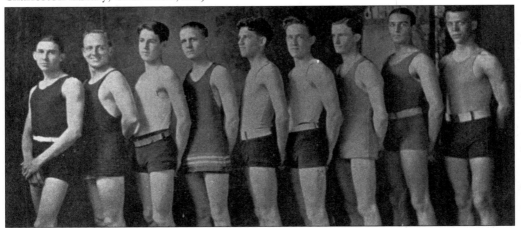

SWIMMING, *C.* **1920.** Swimming competitions were held in the Ashley Hall "kettledrum" and at the YMCA on George Street. It was a custom of the YMCA for men to swim in the nude. The College of Charleston had a co-ed swim team so bathing suits were worn for the competitions against the College. On one occasion a YMCA member walked into the middle of the meet nude, not knowing there was going to be a competition that day. He ran out red-faced and no one ever saw who it was. (Courtesy of Special Collections, College of Charleston Library, Charleston, SC.)

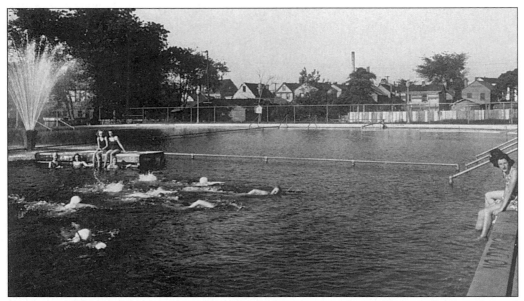

THE CO-ED SWIMMING TEAM, 1939. In this year there was a telegraphic meet with Duke and the University of Georgia. Each team performed before judges and telegraphed its scores to the others to avoid having to travel. The pool on George Street was the reservoir of the Municipal Water Works, housed in the beautiful Middleton-Pickney House (*c.* 1797). The pool had slanted sides and could not be used for competition. This had to be done at the YMCA. (Courtesy Special Collections, College of Charleston Library, Charleston, SC.)

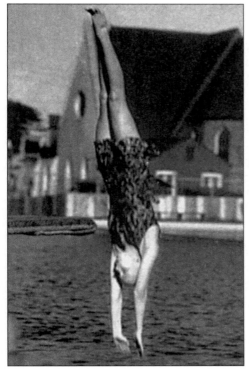

SWIMMING, 1939. Zion Presbyterian was located near the Water Works; it was a fine structure (later destroyed), but is probably not the one shown. (Courtesy Special Collections, College of Charleston Library, Charleston, SC.)

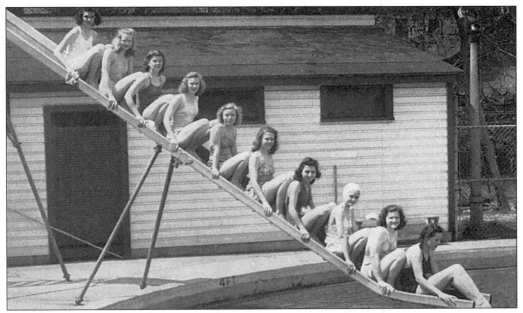

Co-Ed Swimming, 1941. Neither intercollegiate meets nor the telegraphic meet were held that year. The emphasis was on teaching swimming fundamentals. These swimming instructions were in keeping with the original women's movement philosophy that stressed the sanctity of the home and woman's special place in it. America had gone to war and "Boogie Woogie Bugle Boy" was a hit song along with "Chattanooga Choo-Choo" and "Deep In the Heart of Texas." Stan Musial batted .426 for the St. Louis Cardinals, and Humphrey Bogart starred in *The Maltese Falcon*. (Courtesy Special Collections, College of Charleston Library, Charleston, SC.)

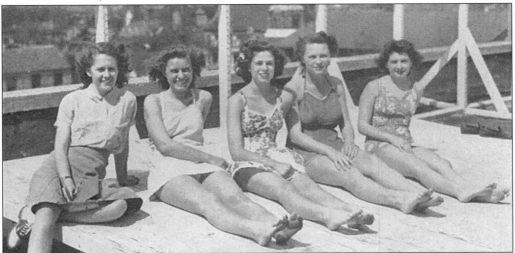

The Girls Swim Team, 1943. Girls' swimming was purely an intramural sport. To have maximum participation they did not compete with other schools, and gave swimming instruction to anyone who wished it. They are pictured sitting on the roof of the gymnasium, a favorite spot for sun bathing. (Courtesy of Special Collections, College of Charleston Library, Charleston, SC.)

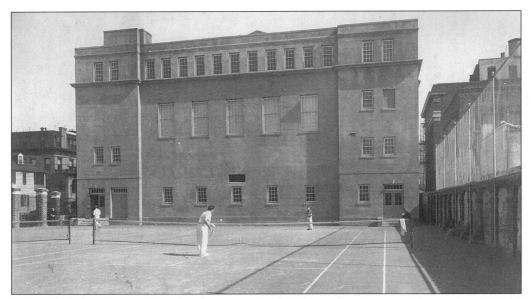

GYM AND TENNIS COURTS. Tennis was a sport in which a small college could compete. Willard Silcox, for many years the college athletic director, went undefeated throughout his collegiate tennis career. Only two other players have achieved this in college history. (Courtesy of Special Collections, College of Charleston Library, Charleston, SC.)

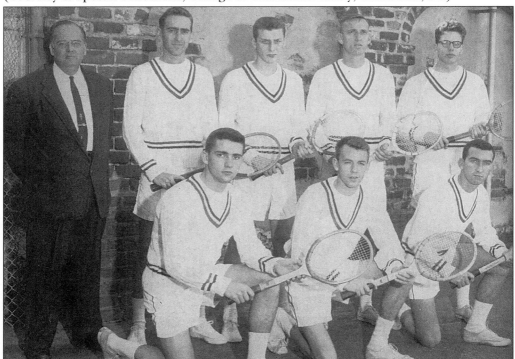

THE TENNIS TEAM, 1957. The College beat the Citadel that year, 5-4, and had 36 wins and one loss in 3 years. Willard Silcox is the coach pictured. (Courtesy of Special Collections, College of Charleston Library, Charleston, SC.)

THE WOMEN'S FENCING CLUB, 1928. This was the first year of the team. By then, women had proven themselves in the College and had entered every college activity. A certain deference to men prevailed, and by custom, the presidency of clubs was never sought by a woman, but the men still felt fairly overwhelmed. (Courtesy of Special Collections, College of Charleston Library, Charleston, SC.)

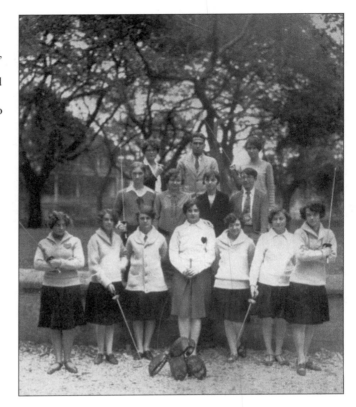

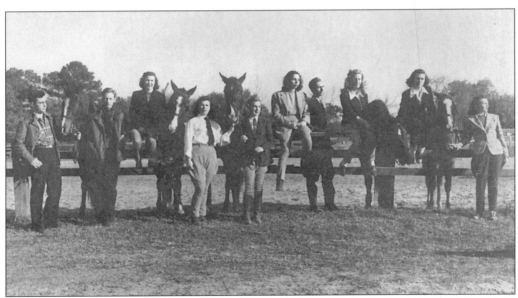

THE RIDING TEAM, 1947. St. Andrews Parish was still rural then, an avenue of oaks lined the Savannah Highway, and the plantations had yet to be built over for subdivisions. The team had classes twice a week at the St. Andrews riding academies and some rode in local fox hunts. (Courtesy of Special Collections, College of Charleston Library, Charleston, SC.)

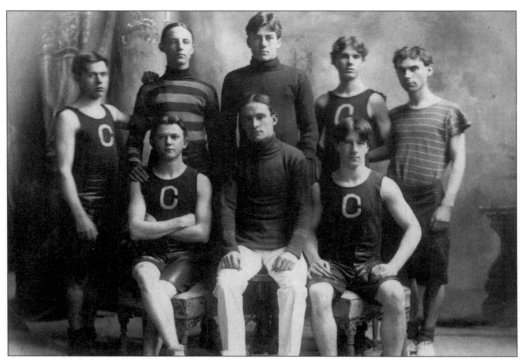

THE TRACK TEAM, *c.* 1900. Track mostly consisted of cross-country, and competition was with various city teams, which included the Citadel (the Sumter Guards) and the Knights of Columbus. (Courtesy of Special Collections, College of Charleston Library, Charleston, SC.)

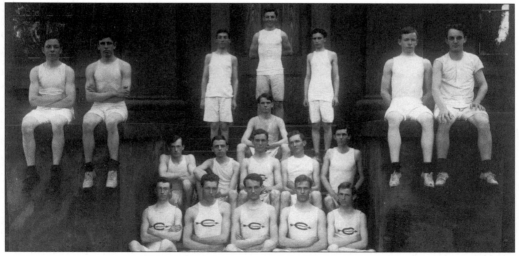

THE TRACK TEAM, 1911–12. A cross-country race was held on Thanksgiving and a 24-mile relay from Summerville to Charleston in December. Anxious for students, the College was very supportive of athletics and would even change exam dates to allow participation. The Citadel excelled at this and won the trophy for many years in this era. In this year, the Citadel was a mile ahead of the rest of the field, but their final runner, blocked by a freight train on John Street, leaped between the moving cars and continued to the YMCA and victory. (Courtesy of Special Collections, College of Charleston Library, Charleston, SC.)

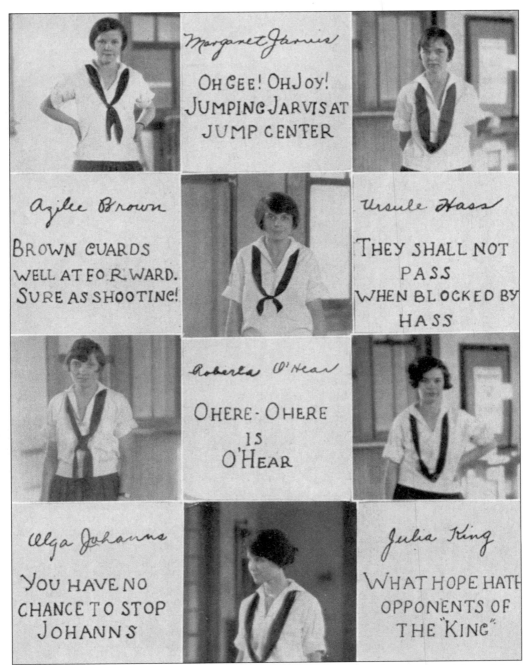

CO-ED BASKETBALL, 1928. Theirs was the uniform of blouses, bloomers, and long black stockings. (Courtesy of Special Collections, College of Charleston Library, Charleston, SC.

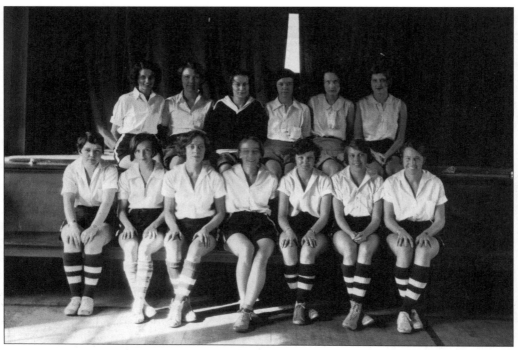

WOMEN'S BASKETBALL, 1931. From the beginning, female educators were concerned that athletics would "unsex" girls and make them unfit for their proper role in life, which was to elevate the moral level of society. Women's sports were modified to promote teamwork and make them less like men's sports with their aggressive competition. To this end, players could not hold the ball for more than three seconds or dribble more than three times. (Courtesy of Special Collections, College of Charleston Library, Charleston, SC.)

Brains VS. Brawn

COLLEGE HUMOR, 1923. The brainy, little wimp is wearing a freshman "rat hat." (Courtesy of Special Collections, College of Charleston Library, Charleston, SC.)

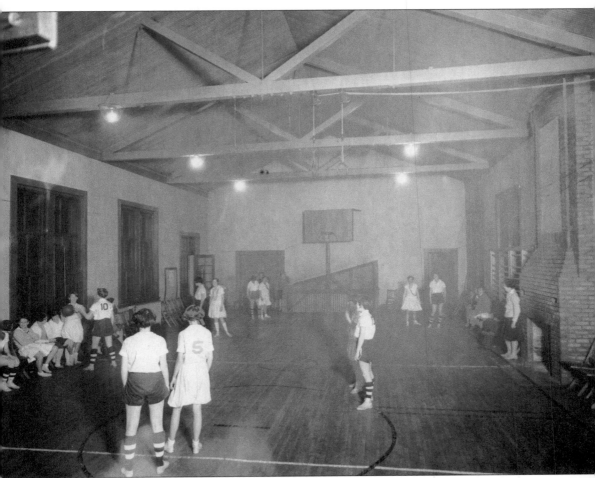

WOMEN'S BASKETBALL, 1930. This gym with a fireplace is hard to identify. The rules had loosened up enough to permit "overguarding"—guarding with two hands not in a vertical plane—but still no snatching the ball. (Courtesy of Special Collections, College of Charleston Library, Charleston, SC.)

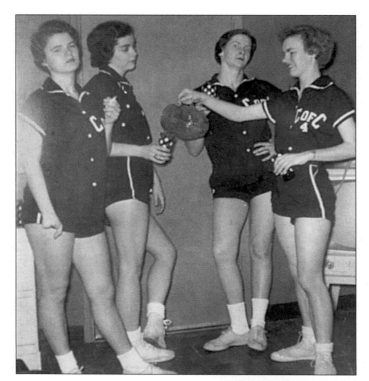

WOMEN'S BASKETBALL, 1956. These Chi Omega sorority sisters all played for the women's basketball team. With 3 wins and 10 losses, it was not a happy season. (Courtesy of Special Collections, College of Charleston Archives, Charleston, SC.)

SCHOOL SPIRIT. This is an early attempt at trick photography. Uldene Hill was not really sitting on the backboard. She was photographed; her image was then cut out and pasted on a photo of the backboard. (Courtesy of Special Collections, College of Charleston Library, Charleston, SC.)

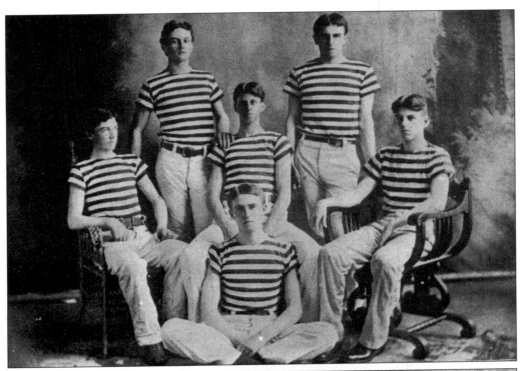

THE BASKETBALL TEAM, 1900. When you consider that basketball was invented in 1892, the College was very much in tune to have a team so early. Baskets were still closed to avoid the referee having to make judgments about whether the ball had gone through. Someone climbed a ladder to retrieve the ball. (Courtesy of Special Collections, College of Charleston Library, Charleston, SC.)

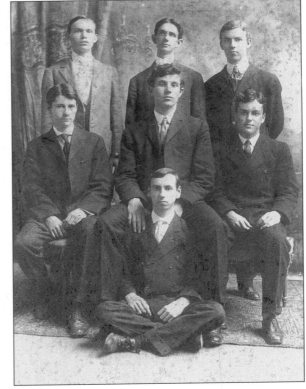

THE BASKETBALL TEAM, 1906–1907. Sports in those days were played against anyone convenient—the City League, the Porter Military Academy, the Navy Yard, the Standard Oil Co., the Charleston South Atlantic League, the Ashley Athletic Club, and sailors off navy ships in the harbor. (Courtesy of Special Collections, College of Charleston Library, Charleston, SC.)

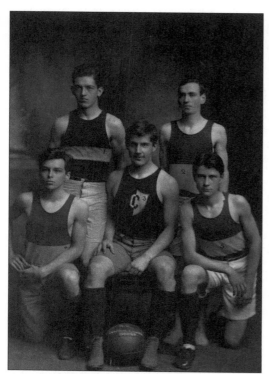

BASKETBALL, 1909. The backboard had been invented to prevent fans from reaching through the net and deflecting the ball. Much of the sports competition was within a city league that included the College, the Citadel, the YMCA, and the Medical College. Yes, the Medical College even had a football team in this era. (Courtesy of Special Collections, College of Charleston Library, Charleston, SC.)

BASKETBALL, 1912. The inscription on the photograph reads "state champions," but this title is something of a mystery. The College played six games that season; they beat the Citadel two of three games and lost once to Clemson. The basketball games were played at the Sumter Guard Armory behind Trinity Methodist or on the stage at Memminger Auditorium. The court was small, but they played full court games. (Courtesy of Special Collections, College of Charleston Library, Charleston, SC.)

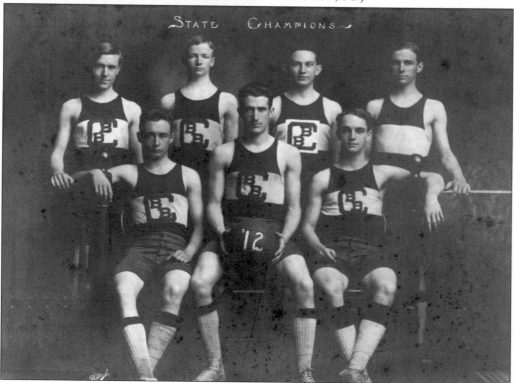

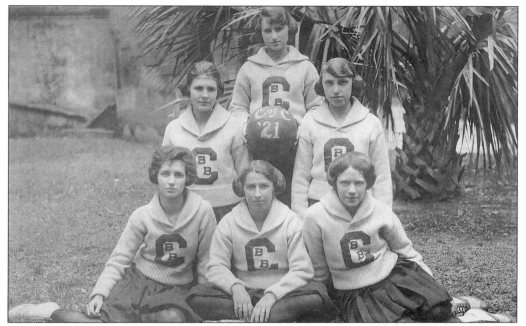

CHEERLEADERS, 1920. As soon as girls came to the College they formed a cheerleading squad. "All ye Rooters: Get ginger! Get megaphones! Get some more pep! Get your voices in good shape! Get your cowbells and other melodious rooting instruments! Get everything that has made the Collegians in the past famous for the support that they give their team!" (Courtesy of Special Collections, College of Charleston Library, Charleston, SC.)

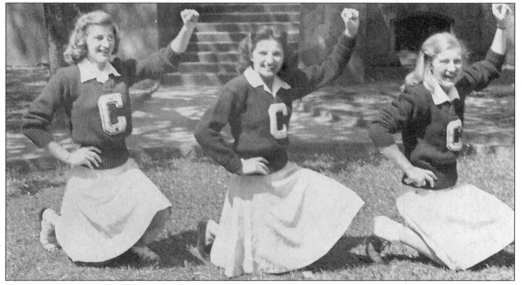

CHEERLEADERS, 1947. The squad arranged the annual pep supper that opened the basketball season. Shown here are Joan Geilfess, Katina Corontzes, and Anne McDonald. A scandalous cheer of the time went: "Idi, didi, God all mighty! Who the hell are we? Slam, Bam, Goddamn! Mighty C of C!" (Courtesy of Special Collections, College of Charleston Library, Charleston, SC.)

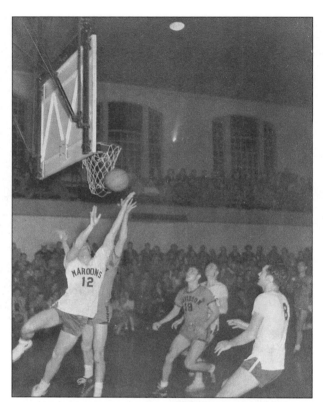

BASKETBALL AGAINST DAVIDSON, 1947. Davidson won 67-55. The College dropped football in 1926 and baseball in 1929; it tried boxing for a year in 1929, but then dropped that as well. During the Depression, the sports program shrank to basketball and swimming. The College experienced such financial hardships that in 1958 President George Grice made the students vote among a basketball team, a tennis team, a college annual, or a dramatic society. The students voted for basketball, but the team performed terribly. Adamantly against athletic scholarships, Dr. Grice stated, "The College will never permit any such policy that would involve the hiring of athletes purely on the merits of the person's athletic ability." (Courtesy of Special Collections, College of Charleston Library, Charleston, SC.)

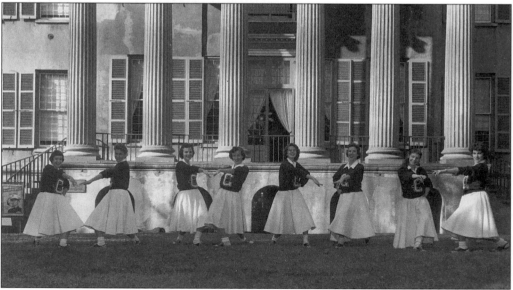

CHEERLEADERS ON THE CISTERN, 1958. This year "Diana," "Satin Doll," and "Splish, Splash" were popular hits. Cocoa Puffs and Cocoa Krispies went head-to-head in breakfast table competition. Arnold Palmer emerged as a famous golfer. Marlon Brando and Montgomery Clift starred in *The Young Lions*. (Courtesy Special Collections, College of Charleston Archives, Charleston, SC.)

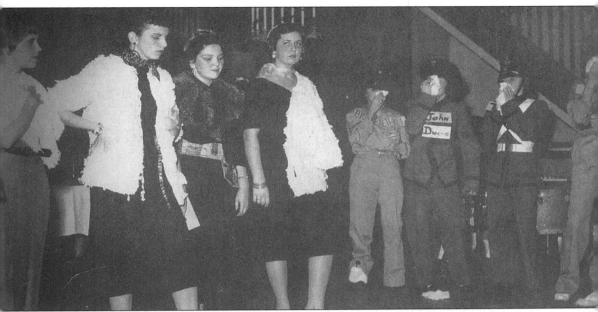

BASKETBALL SEASON, 1957. Baseball and football vanished, but basketball remained hugely popular. The season opened with a pep parade down King Street and around the city, including a snake dance through the library. The scene here is a college skit, with girls dressed in Citadel cadet uniforms. The Citadel and College of Charleston rivalry was always intense and Cadets still continued to try to steal the College victory bell. The tradition of breaking the College bell began after an athletic victory around 1900, when students broke into the janitor's room in the Lodge and carted the bell down King Street in a wagon. Professor Stevenson, then acting president of the College, chased after them, gesturing and threatening expulsion. The bell, being made of cast iron, could be dropped and shattered into pieces, which the students proceeded to do. They then hoisted Stevenson to their shoulders, formed a torchlight parade, and carried him downtown, where he got into the festivity and made a speech. (Courtesy of Special Collections, College of Charleston Library, Charleston, SC.)

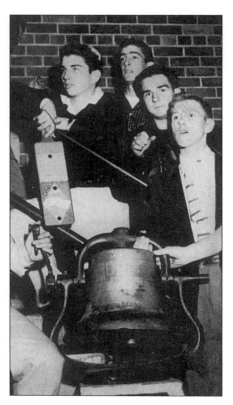

THE COLLEGE BELL, 1955. The Citadel-College of Charleston rivalry was intense from the beginning. Scott Hall, a 1939 Citadel graduate said, "We were always trying to steal their bell, and they were always trying to take our bulldog." Because of a 1931 riot and clashes over the next five years, the two schools ceased athletic competition between 1936–1952. The riot grew out of a tense three-game tournament where the Citadel won the first one and the College the second. The College finally won the third game, 30-26. "The gym was small and we were all packed together, which made things worse," remembers Scott Hall. The game's end resulted in fist fights and College of Charleston students trying to run over cadets with cars. The fire department came and had to hose down a mob of brick-throwing cadets. The clashes continued even though the teams did not play, and in 1941, a group of College of Charleston students cut the rope of the Citadel flagpole. Given the frugality of the times, the Citadel didn't fly a flag until a visiting dignitary questioned its absence, and the College president fined all of the students in order to replace it. (Courtesy of Special Collections, College of Charleston Library, Charleston, SC.)

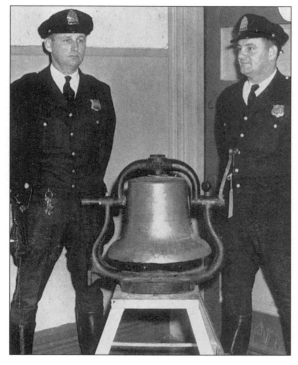

CHARLESTON'S FINEST GUARDING BELL, 1955. The Citadel and the College were playing each other again, and the rivalry was just as intense. College students clanged the bell loudly and Cadets performed a mock funeral march with a dummy dressed in a College basketball uniform. Cadets were lowered from second-tier bleachers to snatch "rat hats." The Citadel won 56-52, and ten minutes before the end of the game College of Charleston Athletic Director Willard Silcox asked the police to escort the bell safely home. (Courtesy of the *Post & Courier*, Charleston, SC.)

Five

EVENTS AND
ORGANIZATIONS

THE FRESHMAN CLASS, 1926. This photograph was taken in front of Main Building (Randolph Hall). In 1926, Buster Keaton was starring in *The Battling Butler*, Lillien Gish and John Gilbert starred in *The Great K&A Train Robbery*, and John Ford made *Three Bad Men*. Bobby Jones won the U.S. Open. Machine-made ice production was soaring, most of it used reportedly to chill illegal liquor. (Courtesy of Special Collections, College of Charleston Library, Charleston, SC.)

THE NICOTINE NINE

OFFICERS

His Smoky Highness: "Egyptian Deity" McLeod
Keeper of the Matches:,... "Sweet Caparol" O'Hear
Chamberlain of the Ash Tray: "Home Run" Hall
Ambassador to Teas and Hops: "Omar" Watson

PLACE OF MEETING:—The Humidor, "111" Smokehouse Ally

MEMBERS

"Egyptian Deity" McLeod "Omar" Watson
"Sweet Caparol'" O'Hear "Helmar" Teague
"Home Run" Hall "Butt Shooter" Ballard
"Violet Milo" Israel "Lucky Strike" Arthur
"Melachrino" Blood

Resolved, That no member shall adopt the style of "cake eater" hair cuts, as this prohi
parking of "choked ducks" behind the ears.

STUDENT HUMOR, 1922. The Nicotine Nine Motto: "Tis better to smoke here than hereafter."
The colors: tobacco brown and smoky grey. The favorite song: "Put on your slippers and
fill up your pipe." (Courtesy of Special Collections, College of Charleston Library,
Charleston, SC.)

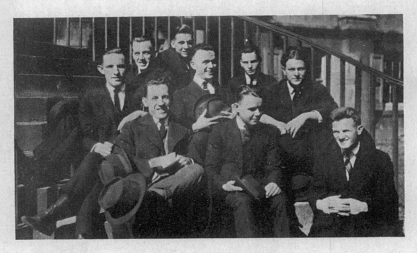

(EX) SHACK CLUB

COLORS:—Dark white and light black.

MOTTO:—"*We will do anything but what is right; if we ever did a good deed, we are sorry.*"

PURPOSE:—To worry the Dormitory Committee

MEETING PLACE:—President's office

MASCOT:—Fannie

OFFICERS

(ex) Chief Water Bag Hurler "Jaybird" Arthur
(ex) Foreman of the Wrecking Crew "Bill" Ballard
(ex) Manipulator of Firearms "Lord" Bryson
(ex) Exalted Uplifter of Honor Committee "Jack" Busch
(ex) Chief Heaver of Furniture "Stobo" Gaston
(ex) Grand Collector of Trophies "Guy" Guyton
(ex) Roller of Dumb-bell "Burbage" Hall
(ex) Moonlight Serenader "Country" Harrison
(ex) Eminent Supreme Formulator of Petitions "Puss" McLeod

All Lovers, Honorers, and Obeyers of the Faculty

STUDENT HUMOR, 1922. The Shack was where out-of-town students lived. It was closed in 1917 and students were obliged to live in rooming houses. From the titles of the club members, it sounds as if they were nothing but trouble to the faculty, which is probably why it was closed. The 1916 college catalogue said, "In connection with the dormitory there is a mess." It didn't elaborate further, but a year later the Shack was closed. (Courtesy of Special Collections, College of Charleston Library, Charleston, SC.)

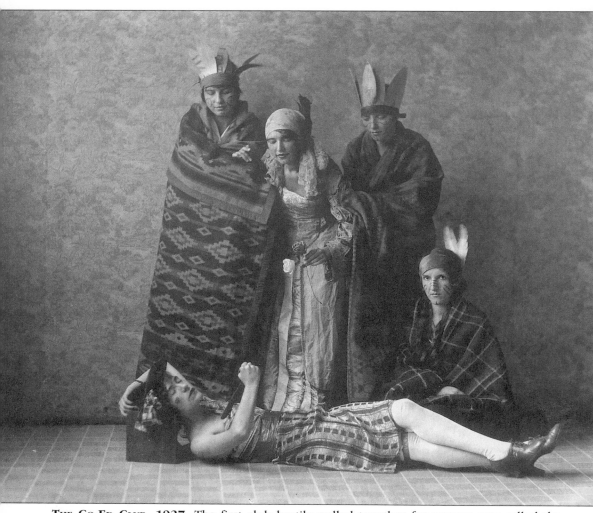

THE CO-ED CLUB, 1927. The first club hastily pulled together for women was called the Co-ed Club. It functioned much like sororities and was ultimately replaced by them. (Courtesy of Special Collections, College of Charleston Library, Charleston, SC.)

ANDROCLES AND THE LION, **1928.** The Dramatic Society performed two short farcical plays, *Androcles* and *The Man Who Married a Dumb Wife*. (Courtesy of Special Collections, College of Charleston Library, Charleston, SC.)

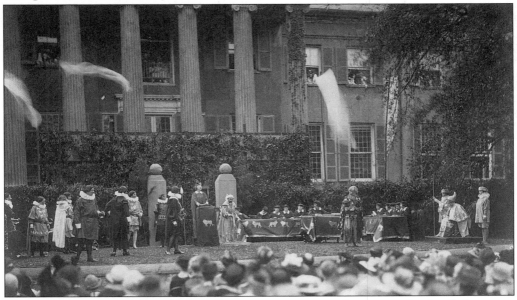

THE SHAKESPEARE FESTIVAL, 1916. College grounds were a perfect setting for the Shakespeare Tercentenary celebration organized by Professor Harris with the help of Ashley Hall and the Confederate Home College. The *Maroon and White* for 1917 read, "The shadows of the oaks, the slanted sunshine, the constant flicker of delicate colors, the coming and going of bright faces, the general pearliness of the afternoon, made a picture which fixed itself in the memory." (Courtesy of Special Collections, College of Charleston Library, Charleston, SC.)

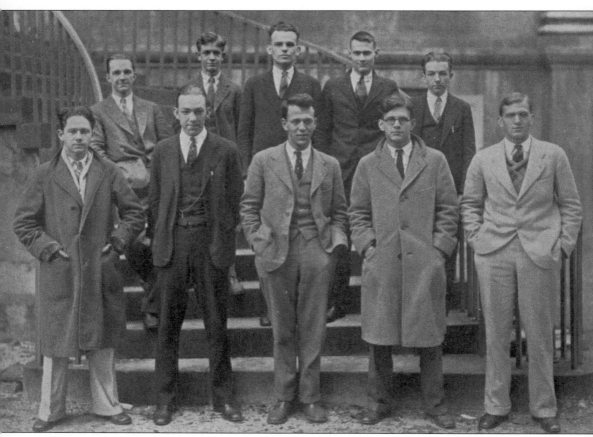

THE CLIOSOPHIC LITERARY SOCIETY, 1926. Founded in 1838, the Cliosophic Literary Society (Clio was the Greek muse of history) was the oldest in the South to survive over the years. It went inactive during the Civil War and again during World War I. In 1922, members of the Chrestomathic became irritated by the "excessive eating of peanuts at compulsory meetings" and withdrew to refound the Cliosophic. The Chrestomathic (meaning "useful to learn") Literary Society was founded at the College in 1848. It first edited the *College of Charleston Magazine*. The 1916 college catalogue warned that these societies would be held responsible for damages done to their rooms during meetings. There was a lot to talk about in 1926. D.H. Lawrence published *The Plumed Serpent*, Hemingway *The Sun Also Rises*, and Faulkner *Soldier's Pay*. (Courtesy of Special Collections, College of Charleston Library, Charleston, SC.)

THE PIERIAN LITERARY SOCIETY, 1931. The Scribblers, the Quill Club, the Chrestomathic, and Cliosophic were all clubs devoted to literary matters. It was the year of Faulkner's *Sanctuary*, Buck's *The Good Earth*, Woolf's *The Wave*, and Miller's *Tropic of Cancer*. (Courtesy of Special Collections, College of Charleston Library, Charleston, SC.)

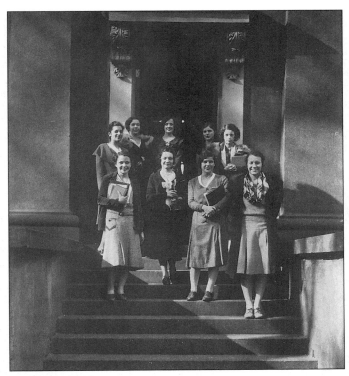

THE COLLEGE OF CHARLESTON MAGAZINE. The magazine was created in 1830, the second undergraduate publication in the U.S. It died a year later and was refounded in 1854. It died again due to a lack of finances, and reappeared a third time in 1888. (Courtesy of Special Collections, College of Charleston Library, Charleston, SC.)

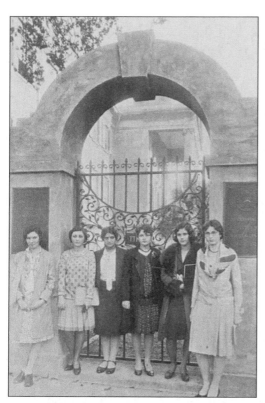

THE SCRIBBLERS, 1930. The Quill Club (founded 1932) and the Scribblers (founded 1929) were literary clubs for women. Meetings were held at homes of the members, where their work was read and criticized by the group. Shown here are Betty Boykin, Lois Hartley, Carolyn McCabe, Julia Myers, and Muriel Trout, founders of the Scribblers. (Courtesy of Special Collections, College of Charleston Library, Charleston, SC.)

THE CHAPEL, MAIN BUILDING. Although the College had no religious affiliation, in a staunchly religious culture, daily Chapel attendance was required around ten o'clock after the second period of classes. Boys sat on one side and girls on the other. When the president prayed, the students stood and faced away from him to "keep the prayers down south." School business was conducted, and misbehaving freshmen had to push a peanut with their noses from the back to the front of the hall. (Courtesy of Special Collections, College of Charleston Library, Charleston, SC.)

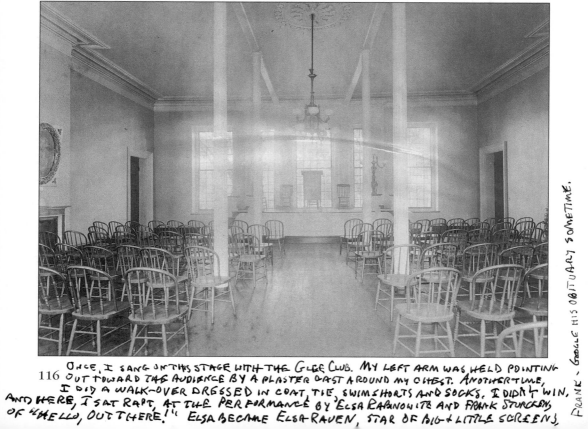

116 ONCE, I SANG ON THIS STAGE WITH THE GLEE CLUB. MY LEFT ARM WAS HELD POINTING OUT TOWARD THE AUDIENCE BY A PLASTER CAST AROUND MY CHEST. ANOTHER TIME, I DID A WALK-OVER DRESSED IN COAT, TIE, SWIM SHORTS AND SOCKS. I DIDN'T WIN, AND HERE, I SAT RAPT, AT THE PERFORMANCE BY ELSA RABINOWITZ AND FRANK STURGEN, OF "HELLO, OUT THERE!" ELSA BECAME ELSA RAVEN, STAR OF BIG & LITTLE SCREENS, FRANK - GOOGLE HIS OBITUARY SOMETIME.

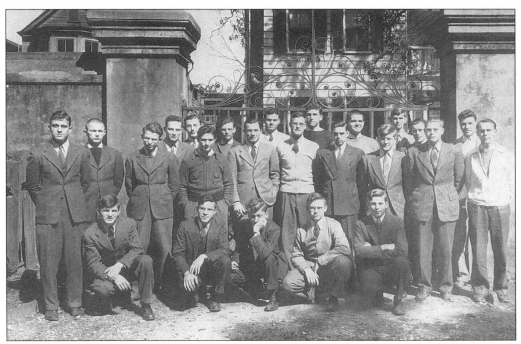

THE PRE-MED CLUB, 1941. The College produced future physicians from the earliest days. This club was founded in the 1922–23 school year. It held six dances the year of this photo and was mocked by some as being no more than a dance society. Club and fraternity initiations were a big event, and the Pre-Med Club was especially known for the rigors of theirs, which was held in the Lodge. It included stepping on a live electric wire, being dunked in the Cistern, and then carried out into the wilds of Johns Island in the night and having to find the way back. (Courtesy of Special Collections, College of Charleston Library, Charleston, SC.)

SENIOR CLASS OFFICERS, 1947. The canteen is on the premises of the old Shack. Sandwiches and soup were also available at the old gym, and eaten on the stage. (Courtesy of Special Collections, College of Charleston Library, Charleston, SC.)

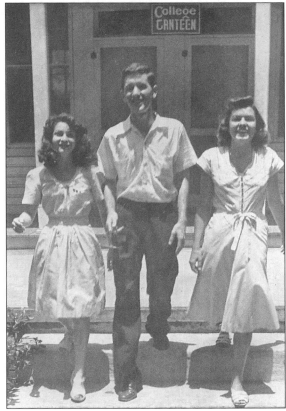

↑ THE COLLEGE CANTEEN OPENED MY FIRST YEAR – 1946. THIS IS WHERE I LEARNED TO PLAY CHECKERS – UNMERCIFULLY INSTRUCTED BY THE RETURNED AIR CORPS VETERANS, WHO HAD HAD LOTS OF HOURS TO FILL.

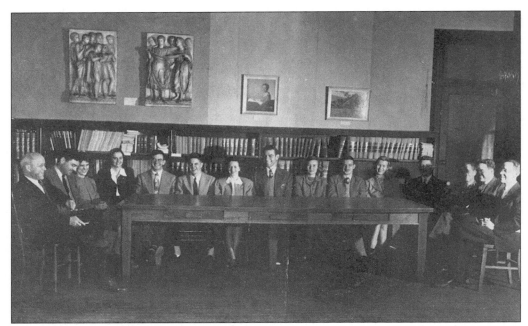

SIGMA ALPHA PHI, 1947. This group was organized at the College in 1942 as an honorary society to encourage scholarship. The plaster casts in the background were brought from England by Gabriel Manigault when he ran the Charleston Museum, and were left behind when the museum moved to Thomson Hall in Cannon Park. (Courtesy of Special Collections, College of Charleston Library, Charleston, SC.)

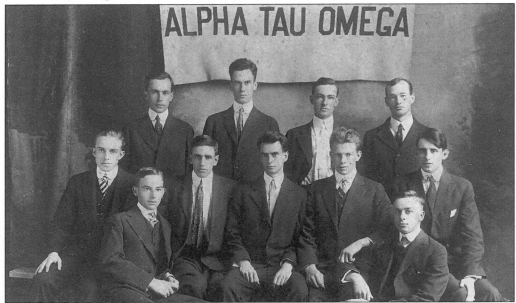

ALPHA TAU OMEGA, 1915. Fraternities did not have houses; instead, they met in rented rooms above stores. "I Didn't Raise My Boy to Be a Soldier" was a popular song of the time. The one-millionth Ford motor car came off the assembly line this year. (Courtesy of Special Collections, College of Charleston Library, Charleston, SC.)

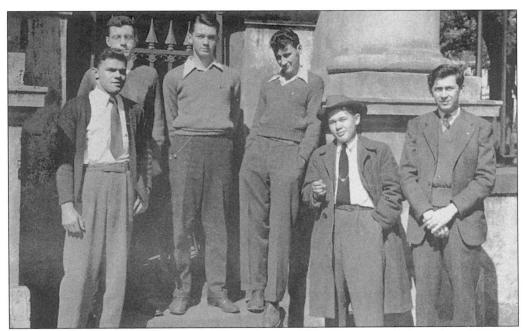

TOLL OF THE WAR. These two photographs, taken in 1945, show the impact of World War II on fraternities and sororities. Tri Delta is full, while Alpha Tau Omega is down to a bare minimum due to the draft. That year, members of Tri Delta complained of a man shortage and the Dramatic Club falling apart because the leading man was drafted out of the play. (Courtesy of Special Collections, College of Charleston Library, Charleston, SC.)

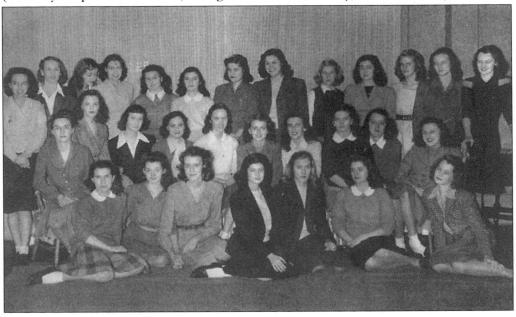

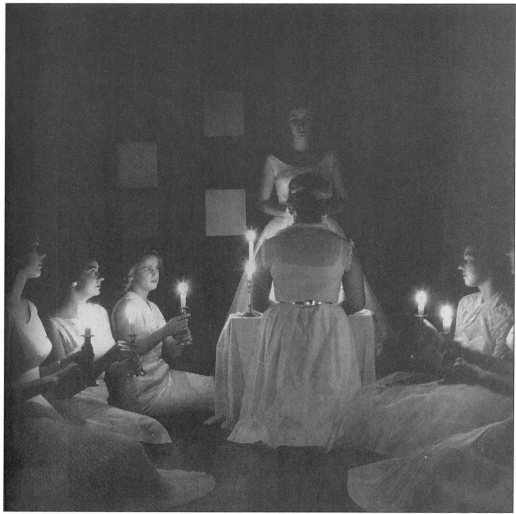

Preference Day, 1957. This picture shows the Tri Delt tradition of candle lighting for rushees on Preference Day. The girls all wear white dresses and shoes, and it is a solemn and special event. The rules are not set in stone, but the tradition of candle lighting is still carried out with the Tri Delts to this day. A sorority sister lights a candle, and the girl holding the lit candle says her rushee's names and it goes on down the line. Other specifics of the ceremonies cannot be revealed. (Courtesy of Special Collections, College of Charleston Library, Charleston, SC.)

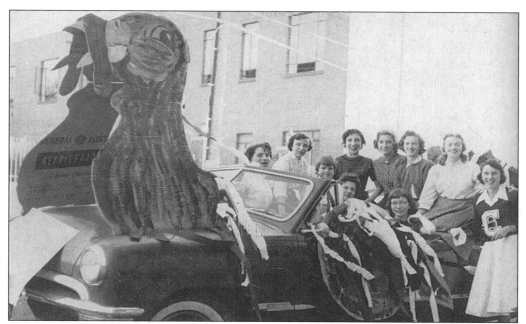

TRI DELTA, 1956. The Alpha Nu chapter of Delta Delta Delta came to the College in 1931. In 1956 it purchased a house at 16 Glebe Street, the only sorority to own its own building. That year they held a Bowery Brawl in February, Spring Formal in April, and a Pansy Breakfast for the graduating seniors in May. Here is their parade float for the pep parade held November 26, hence the Turkey theme. (Courtesy of Special Collections, College of Charleston Library, Charleston, SC.)

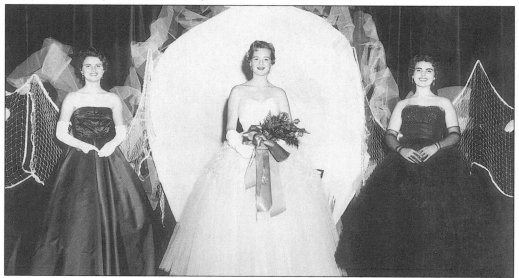

MISS COLLEGE OF CHARLESTON PAGEANT, 1956. The photograph was probably taken in the Francis Marion Hotel. It was the year of "Love Me Tender," "Hound Dog," and "Heartbreak Hotel." *Li'l Abner* and *My Fair Lady* were stage musicals. Miss Clairol asked, "Does she or doesn't she?" *As the World Turns* appeared for the first time on television. (Courtesy of Special Collections, College of Charleston Library, Charleston, SC.)

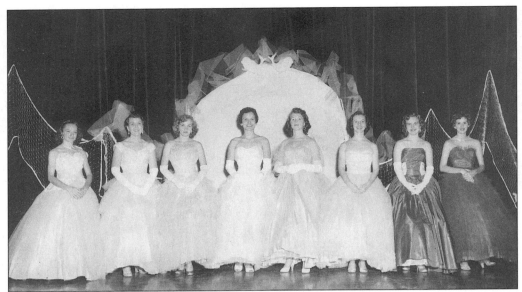

BEAUTY QUEEN AND HER COURT, 1947. "Till the End of Time" was a popular song at this time. Irene Dunne and William Powell starred in *Life With Father*. Maureen O'Hara was in *Miracle on 34th Street*. Sugar rationing ended and Almond Joy came on the market. The 5¢ Hersey bar was really big. Polaroid sold a Land Camera that developed the film within its body in 60 seconds. (Courtesy of Special Collections, College of Charleston Library, Charleston, SC.)

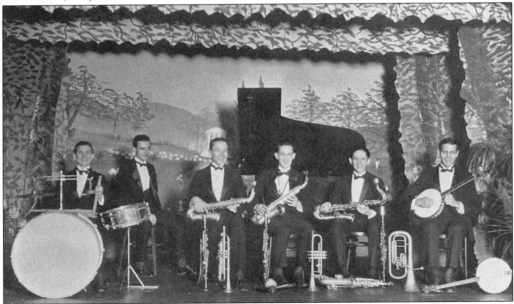

THE COLLEGIANS, 1925. The College band played popular songs like "Yes, Sir, That's My Baby!," "Sleepy Time Gal," and "Sweet Georgia Brown." The "Charleston" hit Paris, introduced by "Bricktop," who arrived broke from Harlem and wound up running a nightclub in the Place Pigalle. (Courtesy of Special Collections, College of Charleston Library, Charleston, SC.)

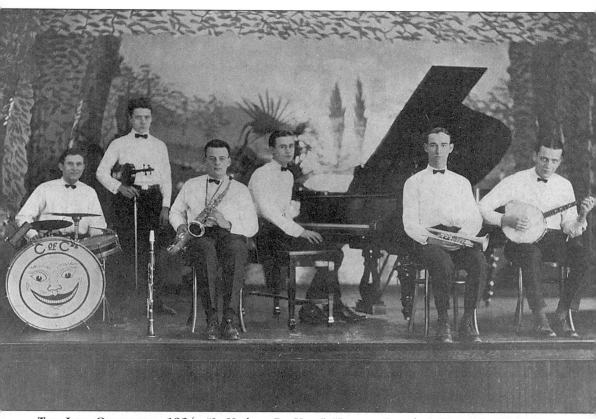

THE JAZZ ORCHESTRA, 1924. "It Had to Be You," "Barney Google," "Yes, We Have No Bananas," and "Tea for Two" were popular songs. The 1924 *Comet* described the student body as "spell-bound by the enchanting orgy of magical sound which issues forth from the instruments of our illustrious syncopaters." (Courtesy of Special Collections, College of Charleston Library, Charleston, SC.)

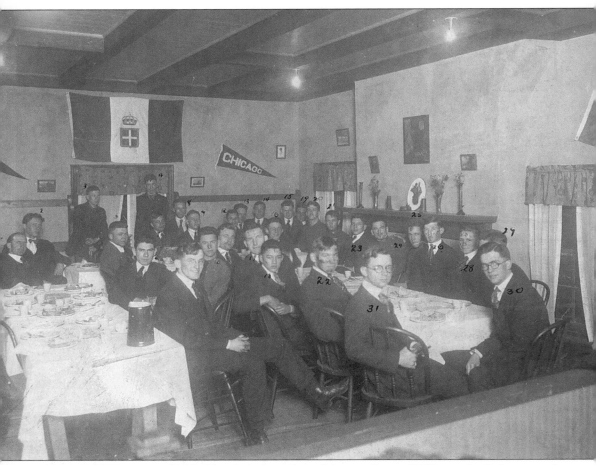

THE YMCA BANQUET, 1919. The American Expeditionary Force (AEF) was back home and everyone sang "How 'Ya Gonna Keep 'em Down on the Farm After They've Seen Pa-ree?" Women got the vote, electric starters became optional on the Model T Ford, and dial telephones were introduced despite a threat of an operator's strike. (Courtesy of Special Collections, College of Charleston Library, Charleston, SC.)

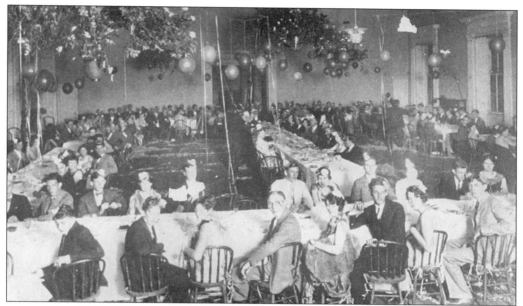

A Pep Supper, 1925. The word "pep" defines the desired image of American college kids in the 1920s. The annual ritual of the pep supper was held on Armistice Day, which celebrated the end of the First World War. It opened the basketball season. In 1925, 150 students attended the supper at the YMCA. The collegians provided the music and played "How Come You Do Me Like You Do." The *Comet* reported of the 1934 supper, "The menu was very attractive consisting of a plate supper, ice cream, coffee, cakes and lots of rolls for the boys to throw about. Dr. Gallardo's speech was concerned with politics so only a select few paid attention." The cost for dinner was $1.25. (Courtesy of Special Collections, College of Charleston Library, Charleston, SC.)

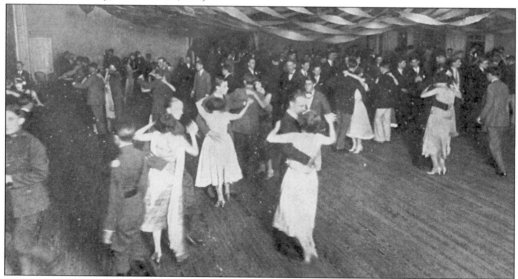

Dance, 1925. The pep supper was always followed by a dance. And of course the band played "Hard Hearted Hannah, the Vamp of Savannah." (Courtesy of Special Collections, College of Charleston Library, Charleston, SC.)

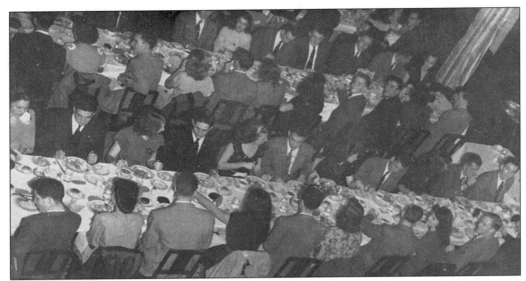

PEP SUPPER, 1947. It was exceptionally festive because the men were back from World War II. (Courtesy of Special Collections, College of Charleston Library, Charleston, SC.)

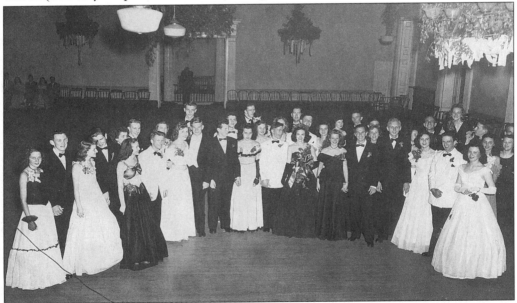

PI KAPPA PHI ROSE BALL, 1948. This fraternity, original to the College, was founded in 1904 by Harry Mixon, Simon Fogarty, and Andrew Kroeg as a non-fraternity called "Nu Phi." Now it is national in scope with over 100 chapters. The non-frat concept was probably the result of Populist governor "Pitchfork" Ben Tillman, who vowed to outlaw Greek-letter fraternities as well as the "dude factory" at the Citadel. He had intimidated most colleges in the state, and the College was one of the few that permitted fraternities. Even during the Depression, students owned dinner jackets and dressed up whenever possible. This very dressy post-war scene in the Hibernian Hall on Meeting Street shows a mix of white and black dinner jackets and even some tails. (Courtesy of Special Collections, College of Charleston Library, Charleston, SC.)

126

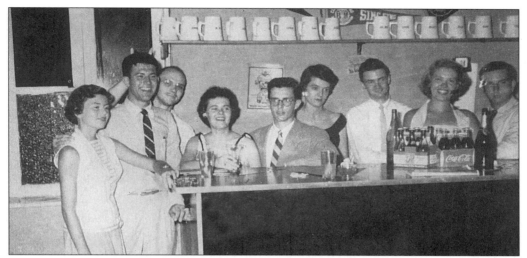

FRATERNITY PARTY, 1957. The *Comet* for that year says, "There's always a frat party, especially when the studying has been hard and everyone has been hibernating in the library. You know you've become a real part of the College when you're in a bubbling circle of friends singing 'Bring out your old silver goblet with the C of C on it'." Records were 45 rpm, and the students listened to "April Love," "A White Sport Coat and a Pink Carnation," and "Bye Bye Love." (Courtesy of Special Collections, College of Charleston Library, Charleston, SC.)

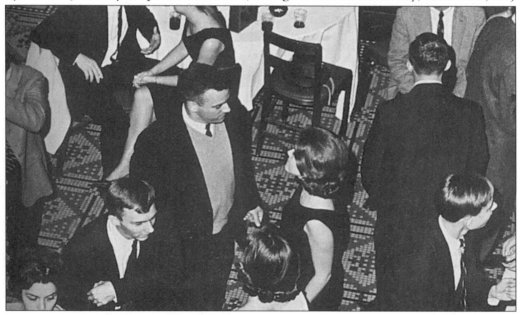

SOCIAL LIFE, 1965. The mini-skirt had appeared in "Swinging London" and Dylan recorded "Like a Rolling Stone." But at the College, the students still dressed up. Parties were still held in the Francis Marion. You can see the familiar mosaic floor. There was no difficulty in getting young men to put on a jacket and tie. It was hard to be a rebel when you lived at home with your parents. Long hair and beards on the boys wouldn't appear until 1971, when the College grew by accepting large numbers of out-of-town students. (Courtesy of Special Collections, College of Charleston Library, Charleston, SC.)

GRADUATION, 1946. Jane Lucas is shown here wearing the traditional white. In her sophomore year, 1943, the class graduated in April. "They couldn't wait until June to get their diplomas. So in April they graduated, got their diplomas and went to war," she recalls. (Courtesy of Jane Thornhill.)

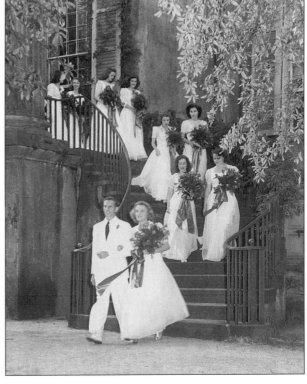

COMMENCEMENT, 1943. Students are seen walking down the steps of Main Building. It has long been a tradition for the women to wear white dresses and the men white suits or dinner jackets. No one can date the exact beginning of the tradition, but it continues with enormous popularity to this day. Graduation was always in the afternoon and was early in history moved from June to May because of the ferocious Charleston heat. (Courtesy of Special Collections, College of Charleston Library, Charleston, SC.)